MOWER COUNTY

MINNESOTA

IMAGES of America

Mower County Historical Society

"Preserving Today for Tomorrow's History"
1303 SW 6th Avenue
P.O. Box 804
Austin, MN 55912

Historical Center
County Fairgrounds

Highway 105 South
Austin, MN 55912

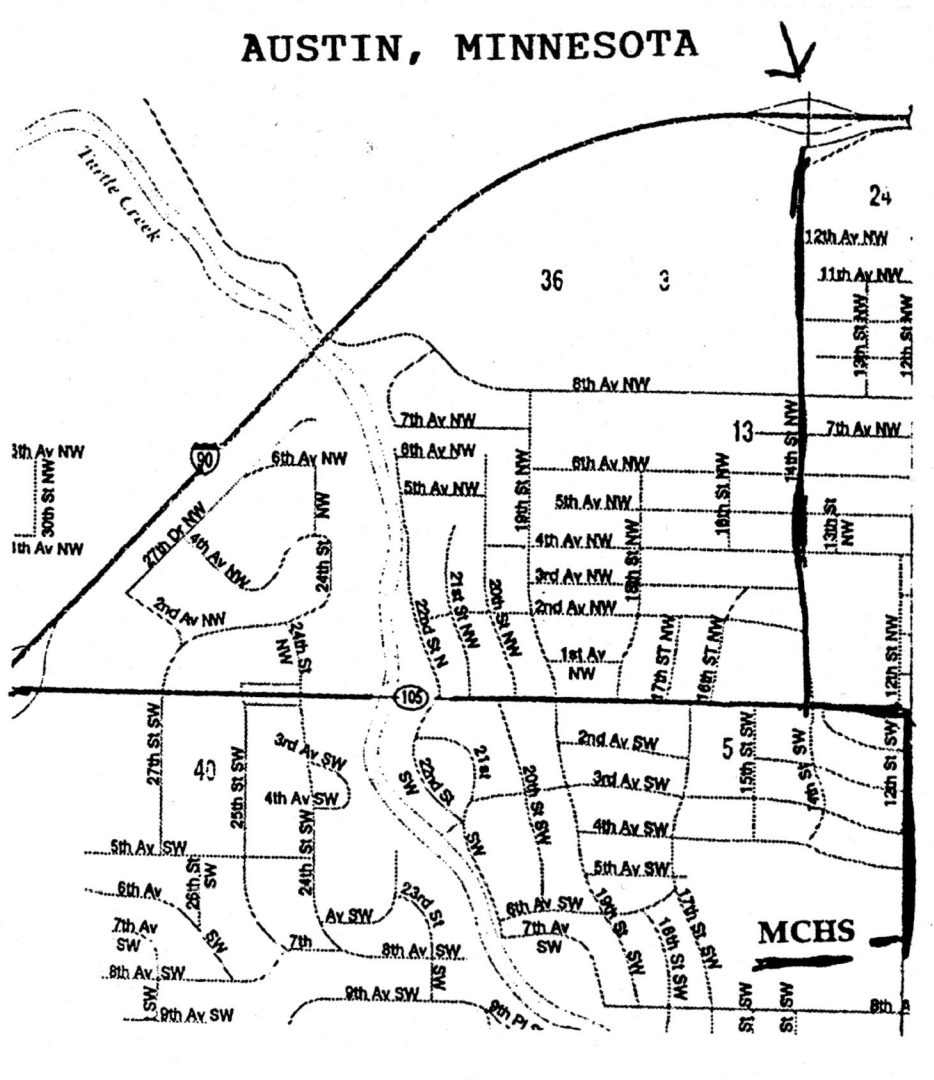

IMAGES of America
MOWER COUNTY
MINNESOTA

Mower County Historical Society

ARCADIA
PUBLISHING

Copyright © 2002 by Mower County Historical Society
ISBN 978-0-7385-1992-0

Published by Arcadia Publishing
Charleston SC, Chicago IL, Portsmouth NH, San Francisco CA

Printed in the United States of America

Library of Congress Catalog Card Number: 2002106073

For all general information contact Arcadia Publishing at:
Telephone 843-853-2070
Fax 843-853-0044
E-mail sales@arcadiapublishing.com
For customer service and orders:
Toll-Free 1-888-313-2665

Visit us on the Internet at www.arcadiapublishing.com

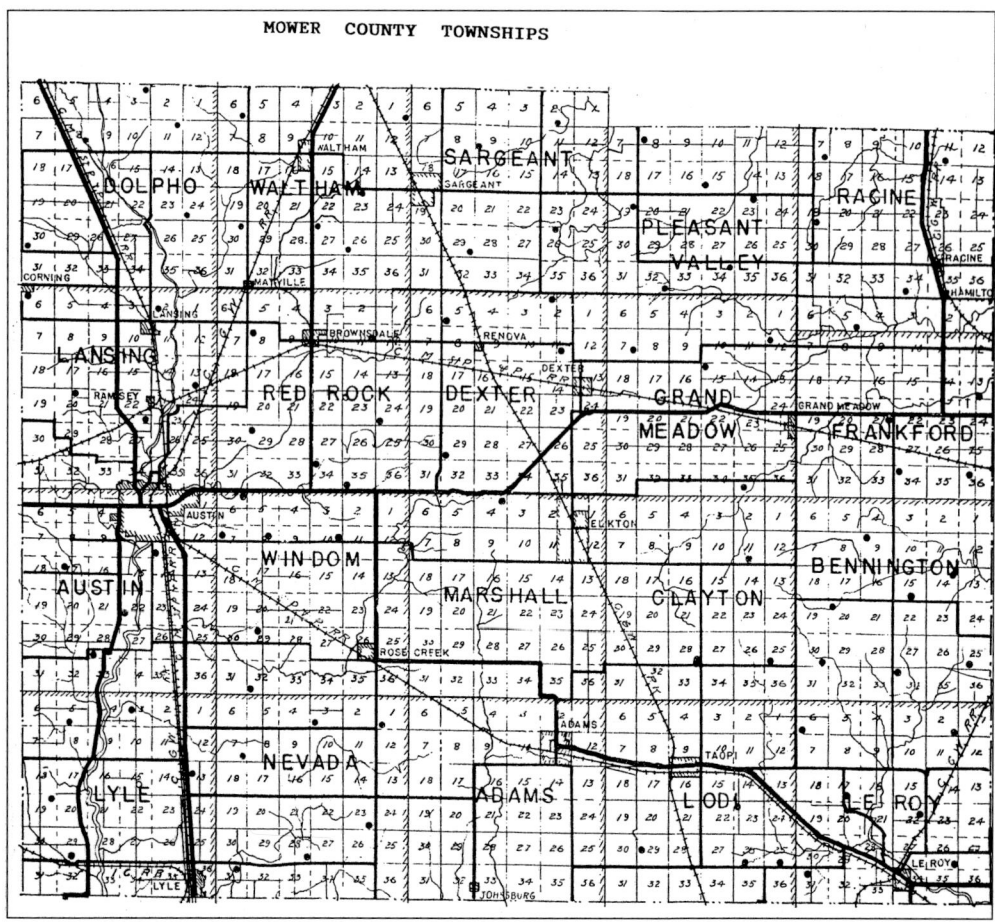

Contents

Acknowledgments 6

Introduction 7

1. Name 'MOWER' 9

2. County Seat 'AUSTIN' 11

3. Udolpho, Waltham, Sargeant, Red Rock, Dexter 13

4. Pleasant Valley, Racine, Frankford, Grand Meadow 35

5. Bennington, LeRoy, Clayton, Lodi, Adams 55

6. Marshall, Windom, Nevada, Lyle 75

7. Austin and Lansing 97

8. Agriculture 119

ACKNOWLEDGMENTS

The Mower County Historical Society is proud to present *Images Of America: Mower County, Minnesota.*

We wish to acknowledge Shirley DeYoung, Mower County Historical Society Executive Director, for weaving these threads of history into narratives that educate and entertain, for coordinating this project with the archival research that provided the interesting images, limitless hours in the photo selection process, valuable information, editing skills, and little known bits of history, for the assembly of the final product

We wish to acknowledge the residents of Mower County who have donated photographs; The *Austin Daily Herald*; and the numerous authors of publications like *Mower County History*

Introduction

The history of Mower County Minnesota is the story of people—their dreams, their hard work, their joys, and their disappointments.

In this book, we will introduce to you ethnically diverse people, and we will attempt to explain the early pioneer natures that braved the hot, sticky summers and the sub-zero winters. In the early years, Native Americans had built mounds and lived in villages along the shores of the lakes. The Europeans arrived later in covered wagons, and some of these earliest settlers lived in dugouts until they could build log cabins. Then came the merchants, who believed in the future of these small farming communities; and the entrepreneurs, who platted sites for the villages.

We have selected prints and photographs from each of our 20 townships that make up our county. In these townships, many communities have developed over the years. Some of them lived only a short time, and died because they were bypassed by the railroads that cross-crossed Southern Minnesota, providing transportation for new settlers and shipping for agriculture products. Other villages could not attract settlers. Those that survived grew, and to this day provide homes for descendants of the earliest pioneers, as well as newer residents, who were drawn by industry or the beauty of Southern Minnesota.

Our early records tell us about the fertile fields, the abundance of crops, and numerous creameries. For many years the largest industry in the county, the meat packing industry, provided jobs for the townspeople as well as a market for the cattle, hogs and sheep raised in the rural areas.

Most all of the photographs in this book are from the files of the Mower County Historical Society. The others have been donated in an effort to further define the communities, past and present, that make up our rural Southern Minnesota landscape. Historical research for the photo captions was done in the Mower County Historical Society library and archives. This library contains an abundance of information—original accounts, as well as other articles written many years after the actual incidents occurred. Research efforts were based on the earliest information possible, keeping in mind that later accounts were often affected by misinterpretation, personal bias, and the prevailing public attitudes. Sometimes only the later information was available.

Although dates, locations, and names are occasionally missing from photo identification, we felt that some pictures were simply too good to be omitted. We ask the readers to provide their own interpretations, knowing that this particular situation did take place sometime in the history of Mower County.

We apologize for any errors that may be found, we tried to do our best to make the information correct.

This book, *Images of America: Mower County, Minnesota*, has been designed as a guide for an afternoon's drive through one of the areas of the county, or a visit to the county seat, Austin. Whether you are in your car, or in an easy chair, and no matter which section of the county you choose, in these pages you will find photos that represent the people, the landscape, the economic purpose, and the lifestyles of each area.

We hope you enjoy your trip!

One

NAME 'MOWER'

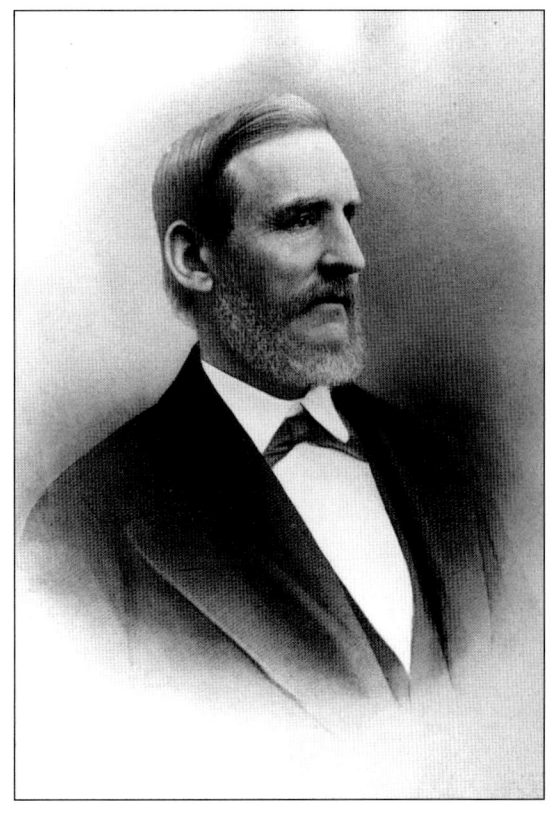

John E. Mower, the man for whom Mower County was named, was born on the 27th of September 1815, in New Vineyard, Franklin County, Maine. He was the eldest of a "good old" New England Family of 13 children. In 1847, the Mower Brothers moved to Arcola, about seven miles north of Stillwater, Washington County, Minnesota. John Mower was honored by his fellow citizens with an election to the fifth and sixth Territorial Councils, and again, in 1875, he was chosen a member of the State Legislature. He was elected by a comfortable majority, running on the Democratic ticket in a largely Republican territory. This is a good indication of his personal popularity in a community where his reputation for honorable dealings in all his transactions with his fellow men and his upright character were so well known.

The territorial legislature gave the name of Mower to one of the counties in honor of John Mower. As a monument to his industry and integrity, Mower County Minnesota, was named for him.

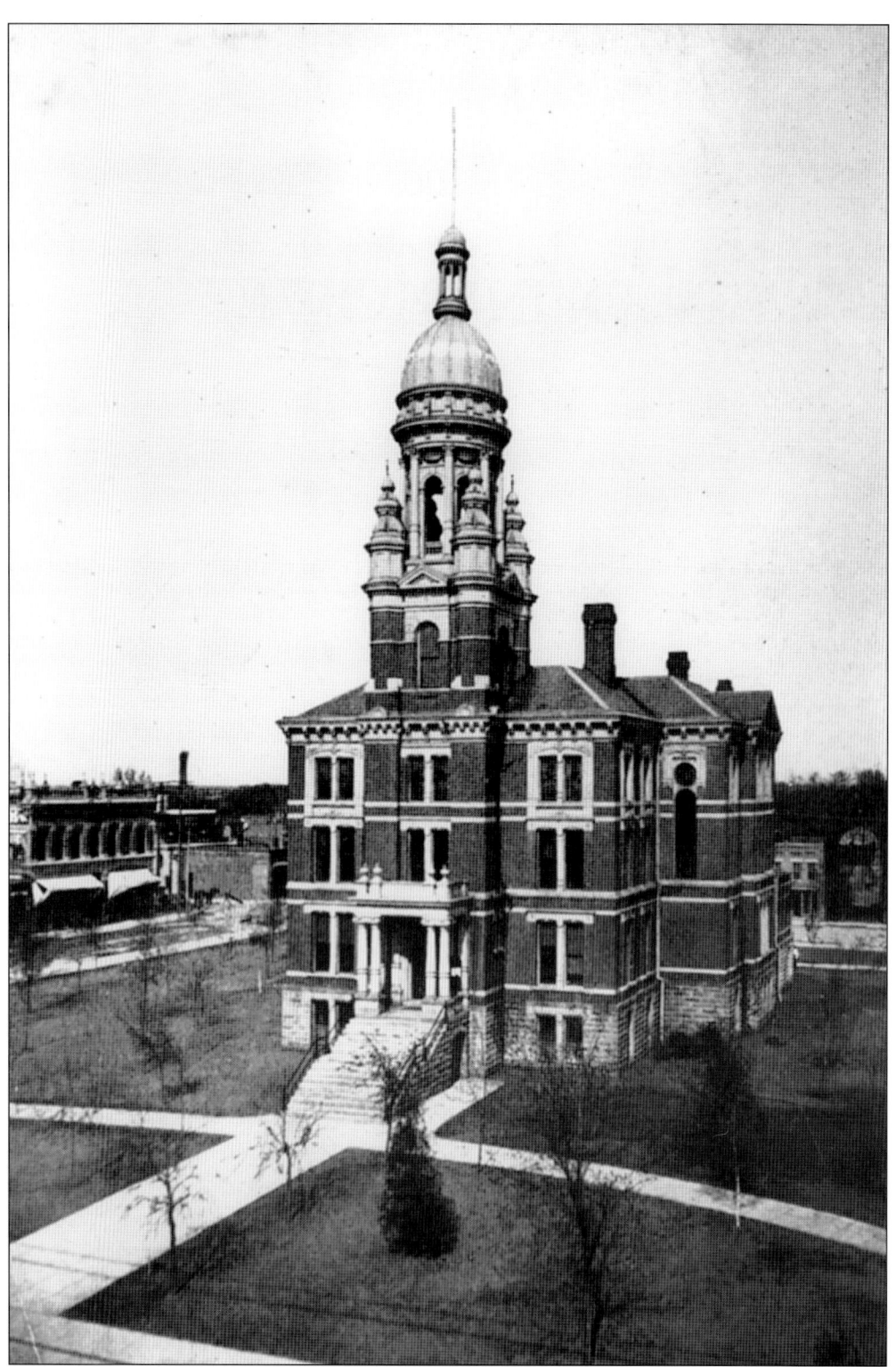
Pictured is the Mower County Courthouse.

Two

County Seat 'Austin'

The location of the county seat was the first official question of importance that occupied the attention of the people of the newly organized county. The first board of the county commissioners was appointed by Governor Gorman in 1856, and its members were George White, Phillip Howell, and William Russell.

On July 6, 1857, the board passed the resolution:

Whereas, it appears by a canvass of the votes cast at an election on June 1, 1857, the majority of the votes were for the location of the county seat on Davison's addition in Austin. Resolved, that we, the commissioners of said county of Mower, at this our regular session, July 6, 1857, in accordance with the wishes of a majority of the legal voters of said county, as expressed by the election, do hereby locate the county seat of Mower County on block 23, in Davidson's addition in Austin.

D.J. Tubbs, whose bid for the Mower County Courthouse was $9,200, was awarded the contract and completed the work in a very satisfactory manner. The new courthouse was completed and occupied in 1884.

Pictured here are Mower County Officials in 1891. They are, from left to right, Alex Requa, county treasurer; S.S. Washburn, probate judge; Fred Wood; Chas H. Wilbour, auditor; Tom Belsinger; Eugene Wood, register of deeds.

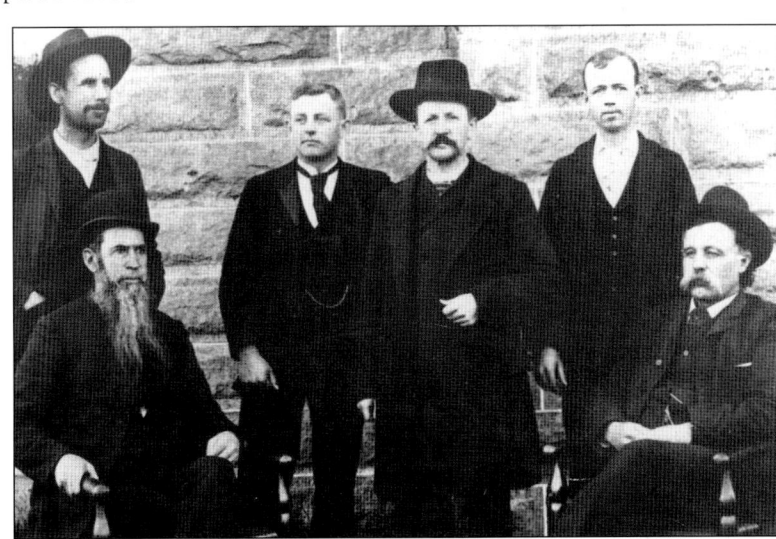

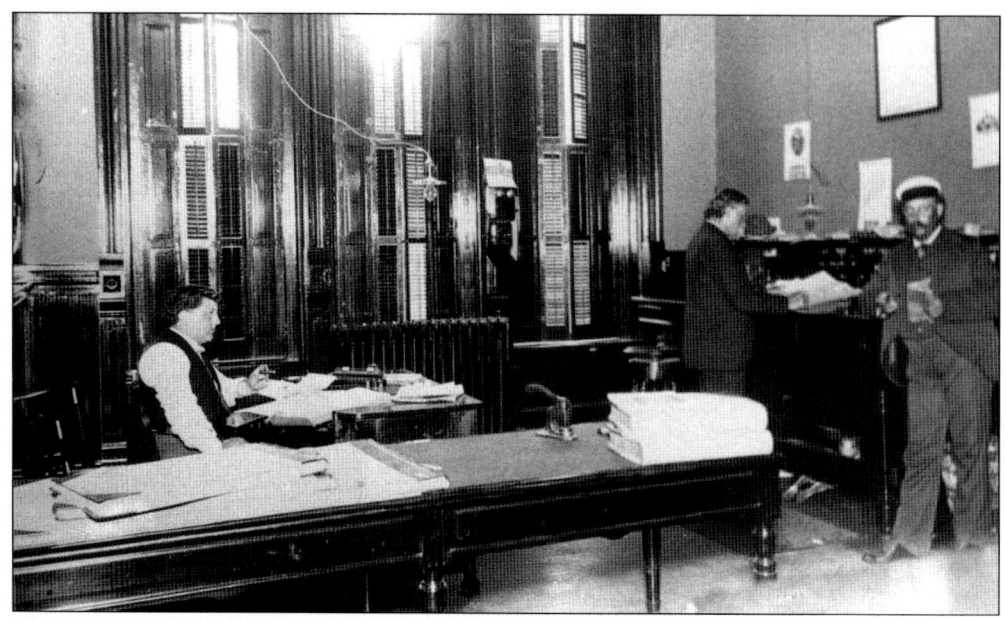
The Register of Deeds' office, J.S. Wood, Mower County Courthouse.

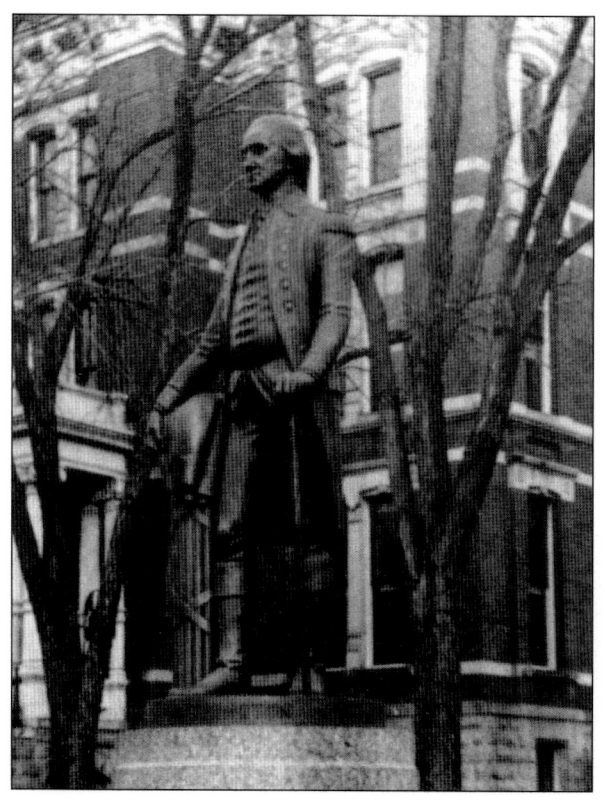
The George Washington Statue on our Courthouse lawn.

Three
Udolpho, Waltham, Sargeant, Red Rock, Dexter

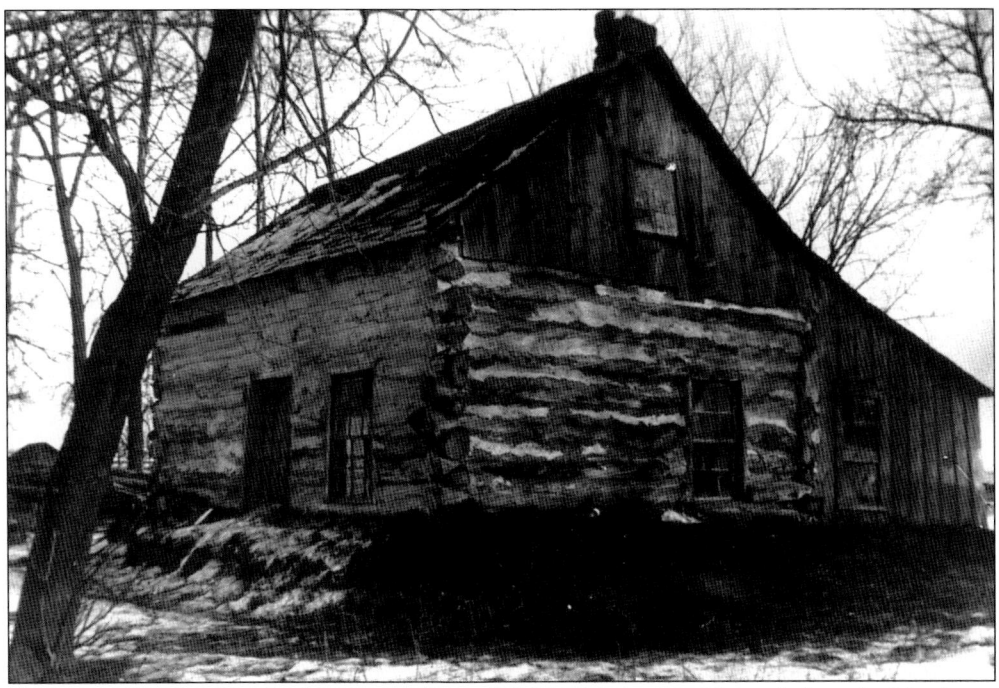

William Tullis is said to be the first settler in Udolpho Township. He settled on the Northeast quarter of section 21, in February of 1855, building a 14-by-14-foot log cabin. His family consisted of his wife and four children.

Mary Stokes LaBar of Udolpho Township was born the sixth daughter of Rev. George and Delane Stokes. Mary married Orlando Clinton LaBar in October of 1869. To Mary and Orlando, three children were born.

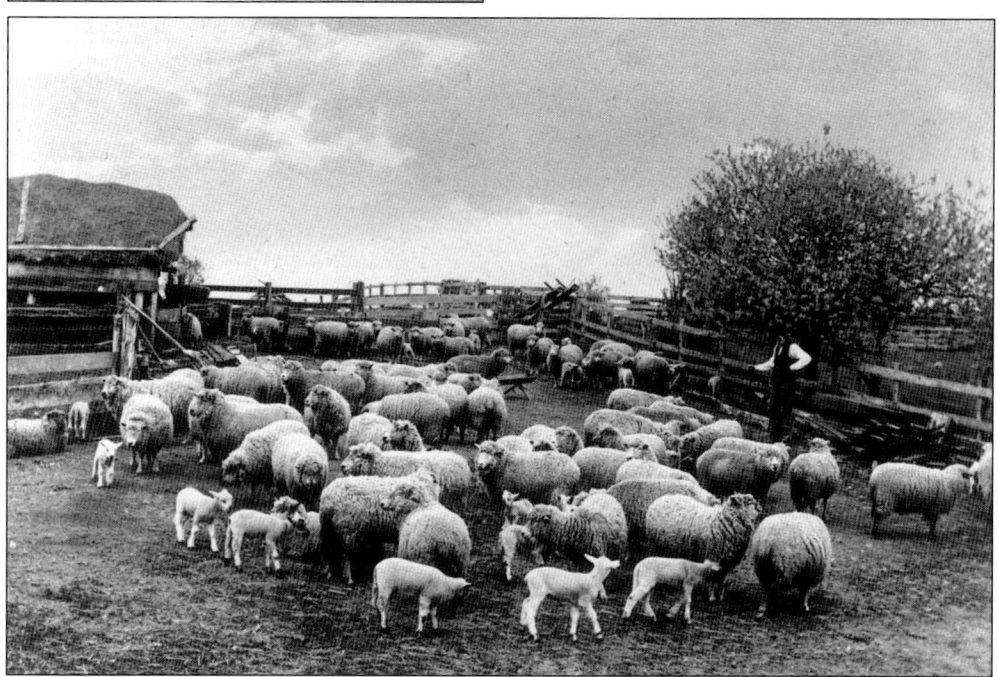

While Mower County was not a sheep raising county, it was a breeding place of thoroughbreds, which were in demand in Montana, Wyoming, and Idaho. The leading breeds in Mower County were Merinos, Cotswold, Shropshire, Southdowns, Lincoln, Oxfords, Hampshires, and Horned Dorsets.

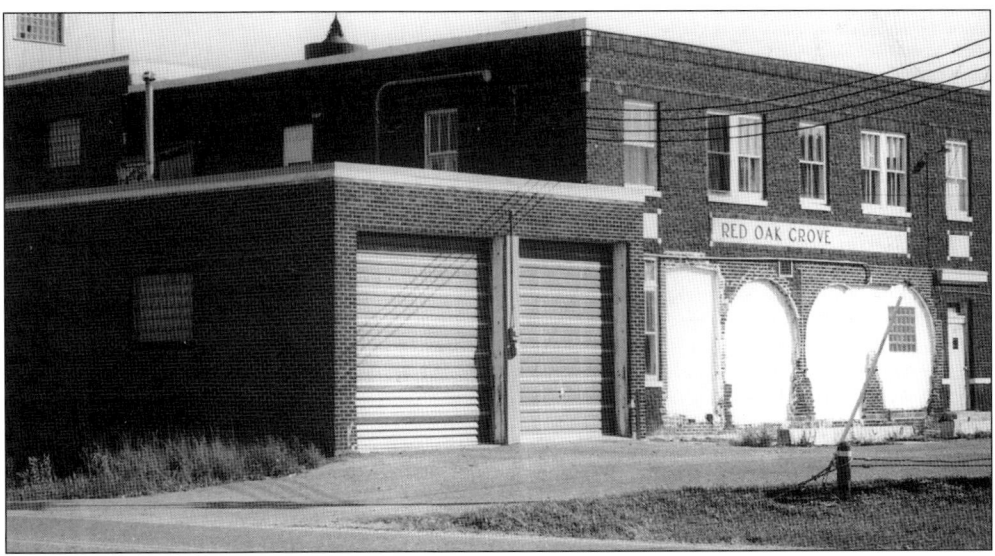

In 1859, the Rev. C.L. Clausen from Saint Ansgar, Iowa, visited the settlement and organized the Red Oak Grove Congregation. Rev. Clausen continued to visit the settlement and hold services in the farmers' houses. The first church building in Udolpho Township was 40-by-18 feet, and was erected in 1869. The name Red Oak came from the fine grove of Red Oak Trees, which were the feature of the landscape of that locality.

The Red Oak Grove Co-Operative Creamery Company was organized in 1892 and was located in the northwest corner of Section 6.

The village of Madison was located on the northeast side of the southwest quarter of Section 21. The village of Madison was platted by Warren Brown in the fall of 1857. The town was a failure, the vacated buildings went to rack and ruin, and eventually the village plot was converted into a wheat field

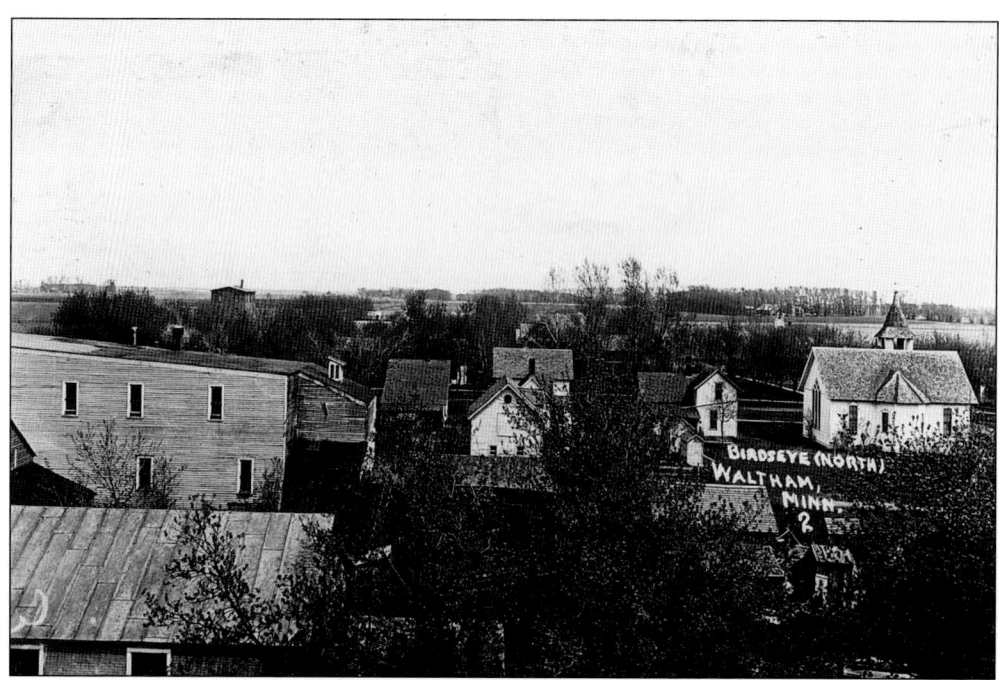

Here is a birds-eye view of Waltham. The name of Waltham was given at the suggestion of Charles F. Hardy, a native of Waltham, Massachusetts.

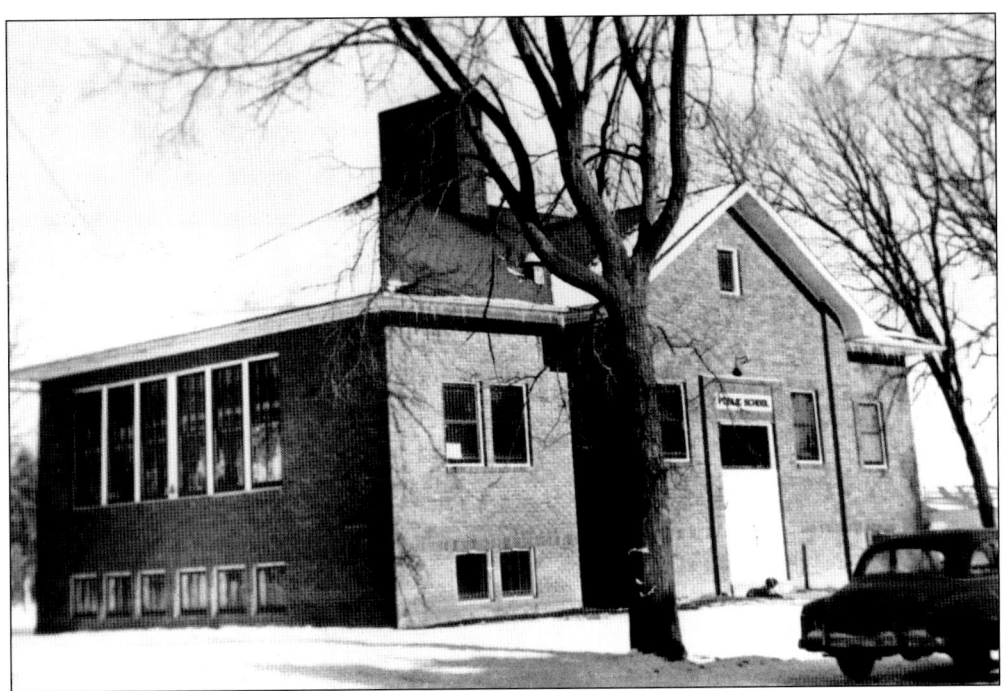
Above is the Waltham Public School.

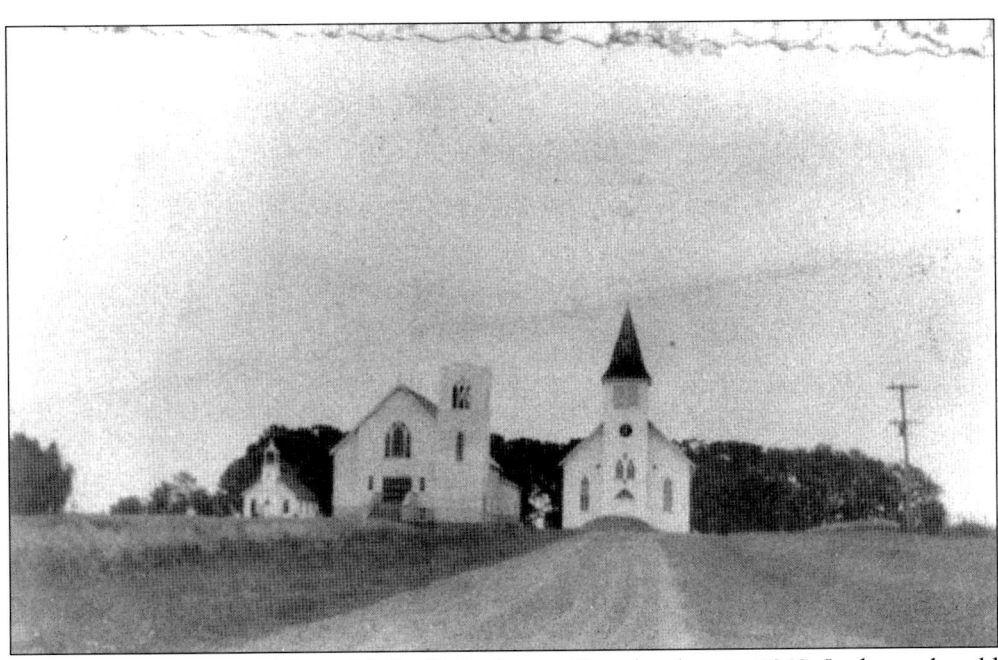
Seen here is a picture of Saint Michael's Lutheran Church taken in 1942. It shows the old school house (1899), the new church (1942), and the second church (1890).

Evangelical Trinity Lutheran Church of Waltham Township was completed in 1895.

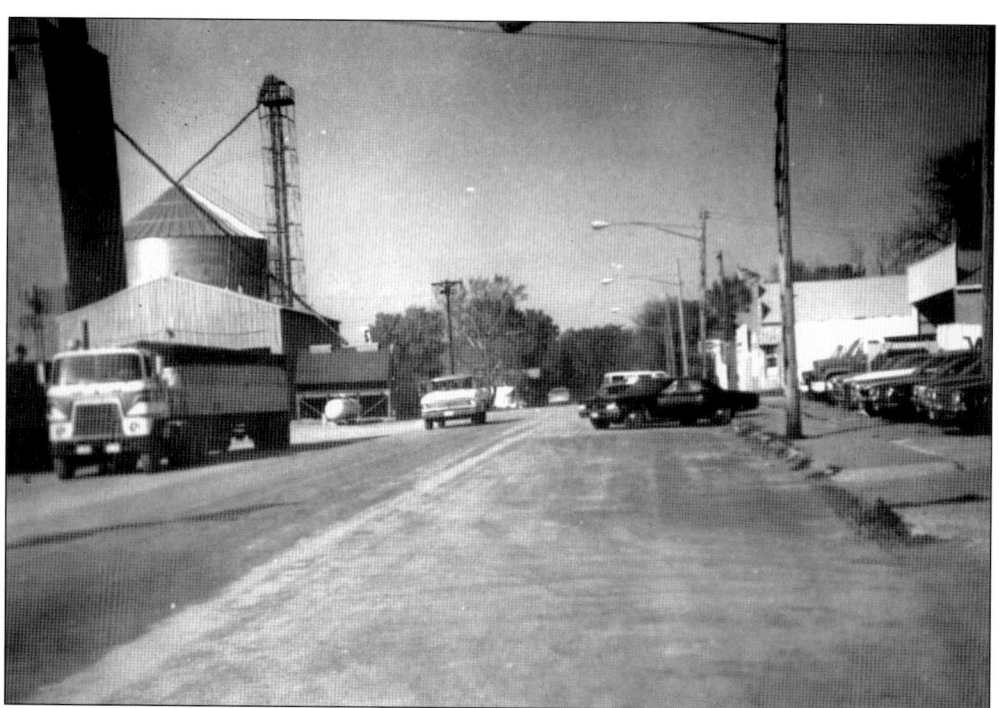

Captured here is a street scene in Waltham. Notice the elevator and large grain truck.

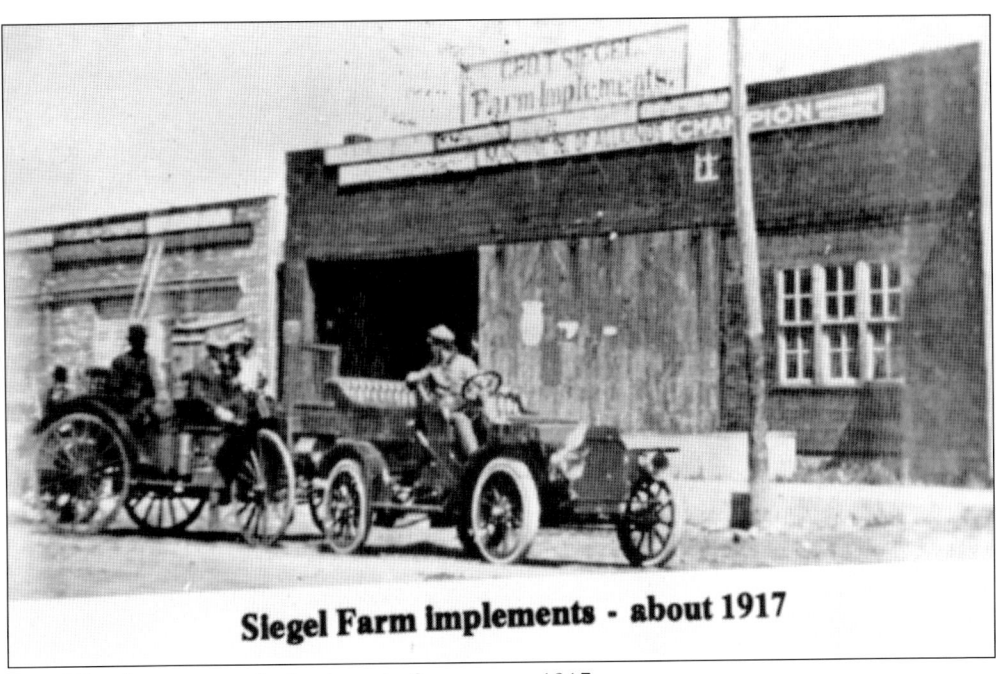

Samuel King settled in Sargeant Township in 1869, on Section 13. Thirty acres were broken and a log house and granary were built.

Siegel Farm Implements - about 1917

Siegel Brothers operated a business in Sargeant, c. 1917.

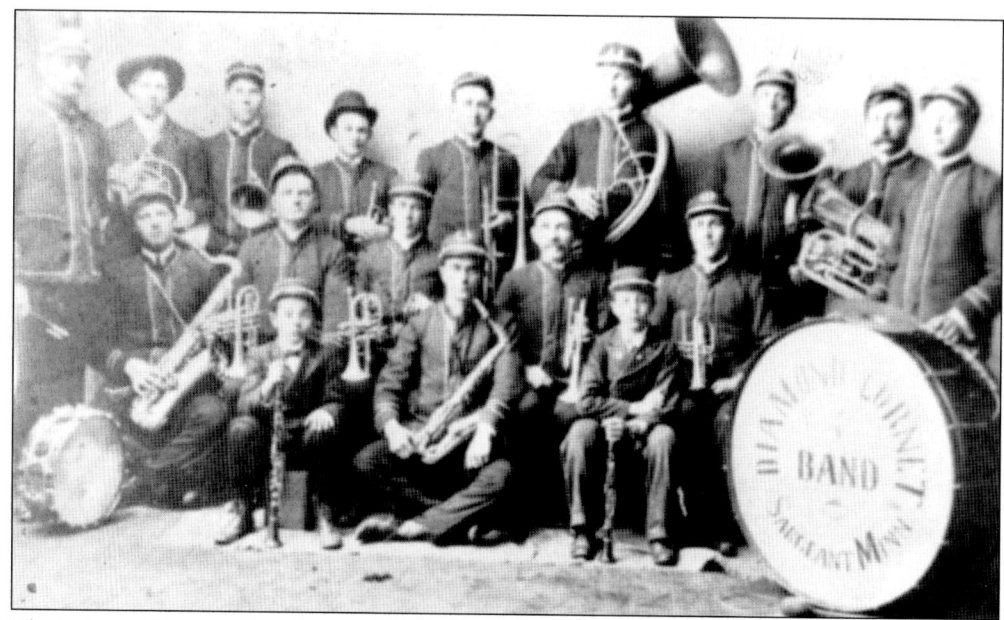

The Diamond Cornet Band is pictured here, from left to right, as follows: (front row) Harvey Schmelzer, George Sieel, and Walter Schmeizer; (middle row) Louis Whitstock, Henry Hanson, Roy Grimm, John Siegel, and Frank Grimm; (back row) Hiram Kezar, Fred Whitstock, Arthur Zander, Fred Kopplin, Fred Schwartz, Oscar Schwartz, William Carver, Jacob Martin, and Amund Strandum.

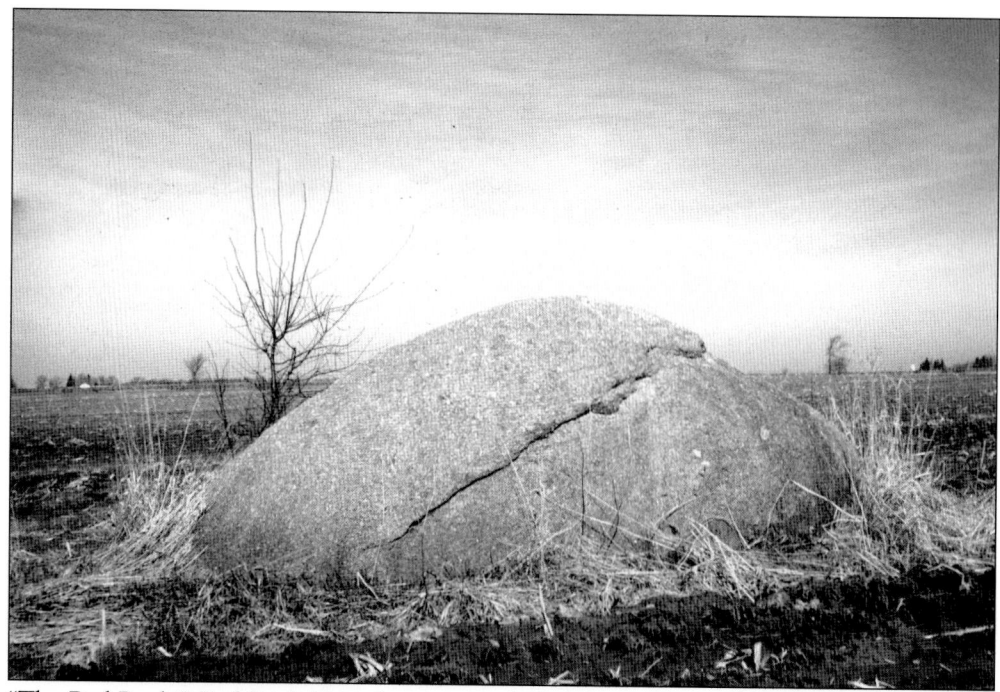

"The Red Rock!" Red Rock Township is named after this rock located one-mile north and a half-mile west of Brownsdale. An item in a Brownsdale leaflet dated May 13, 1891, reads: "A kelm of brick has been burnt during the last week at the pottery, splendid brick was turned."

Mrs. Angeline A. Tanner became the first teacher at the Tanner School in Red Rock Township.

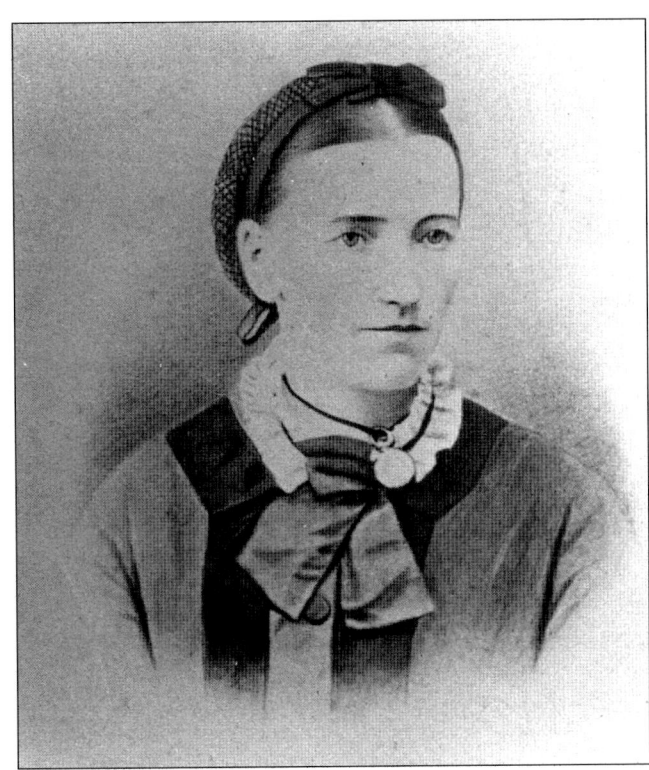

Shown here is the the Vandegrift Cabin. J.M. Vandegrift, a farmer of Red Rock Township, was born in Wilmington, Delaware, in 1849, son of John and Mary Vandegrift. He came to Mower County in 1856 and reared in a log cabin in Section 34.

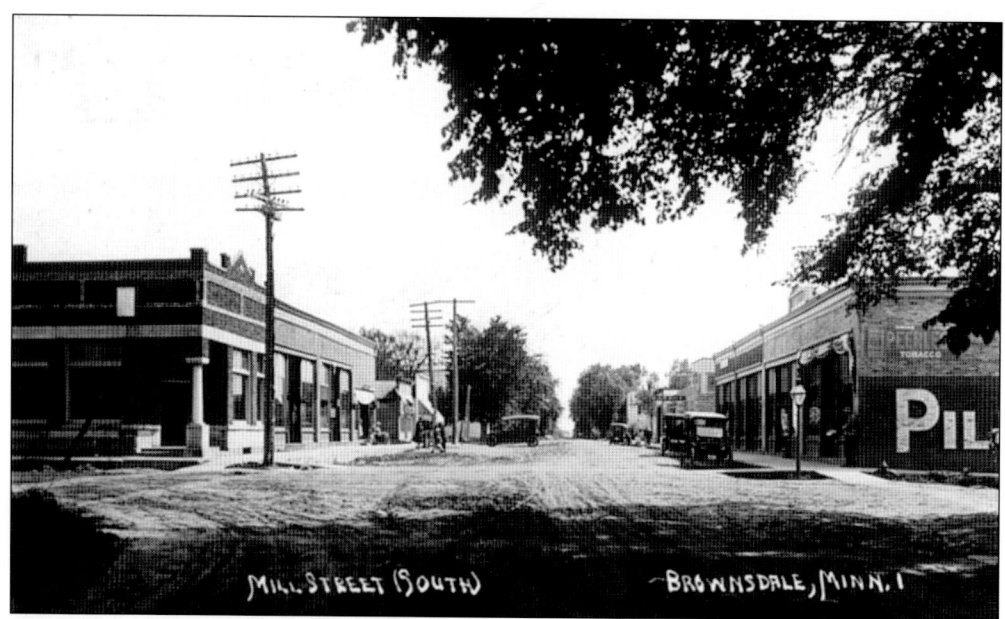

Seen here is Mill Street, Brownsdale. Notice the horse on right side of the picture and the cars parked on the street. The Picture was taken in 1912 and Highway 56, which is pictured, was nothing more than a dirt road.

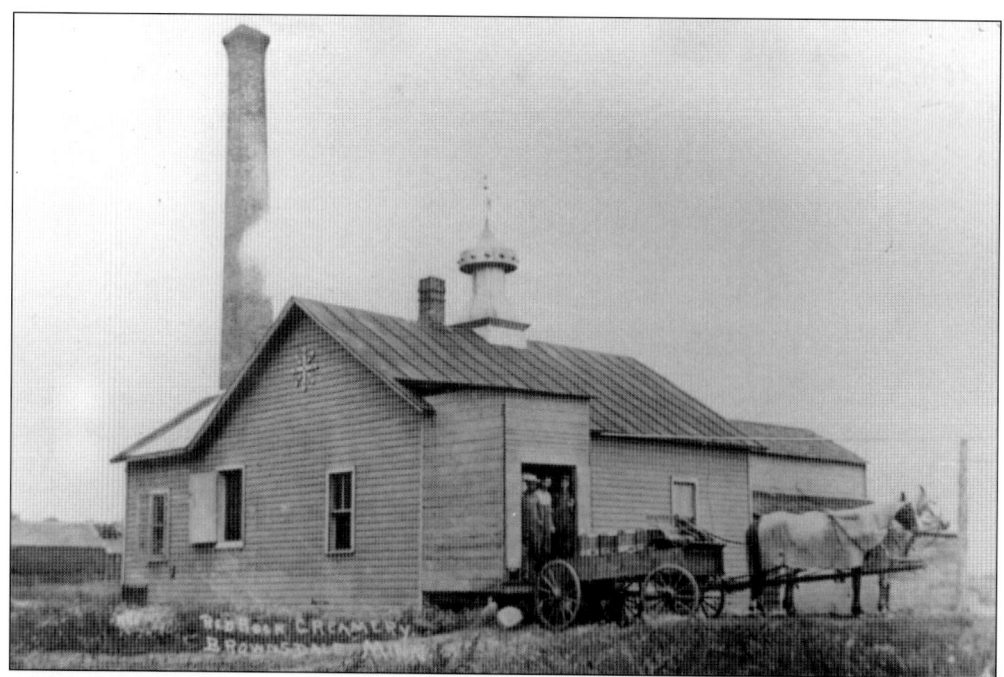

The Red Rock Creamery, Brownsdale, is shown here. The early settlers sold butter for 15¢ to 20¢ per pound. In 1932, butter was 17¢ per pound. Notice the 50-foot brick chimney, which was built in 1905, at a cost of $230.

The Sim's Hotel was located on Main Street in Brownsdale.

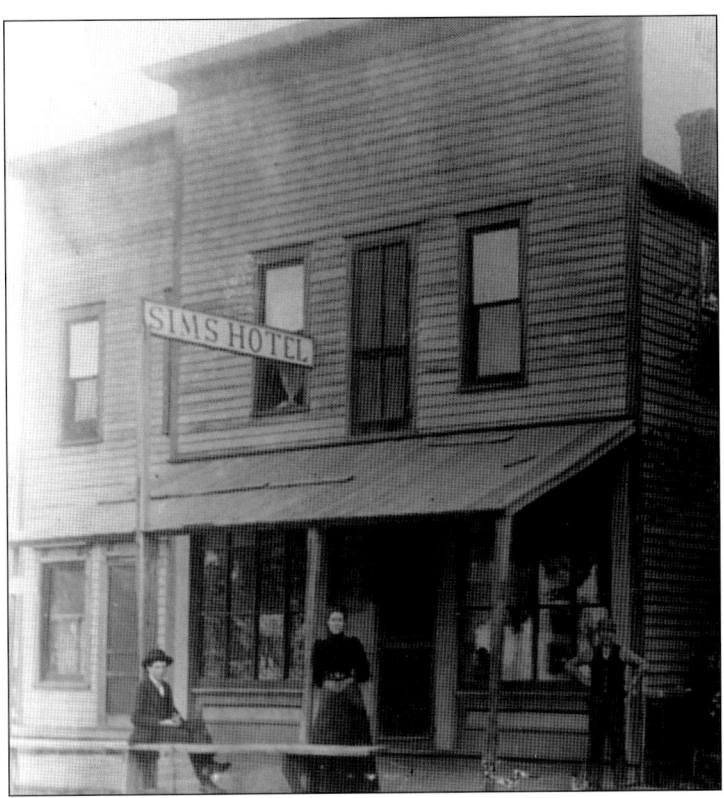

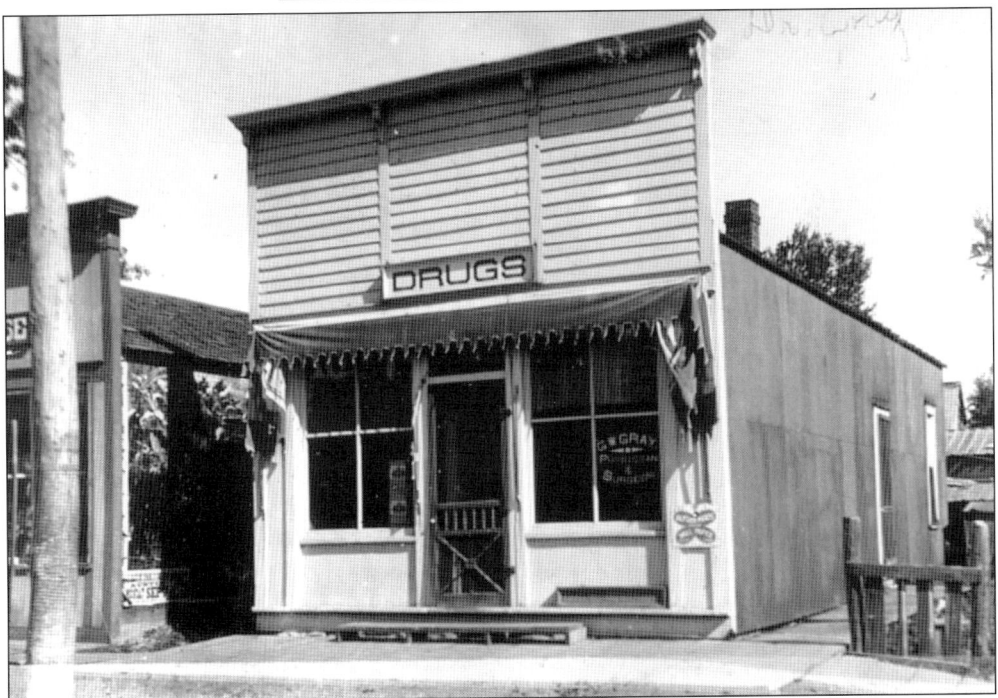

In 1872, Ozro Sleeper owned this Drug Store in Brownsdale. In 1873, his son Ozro joined into partnership with his Dad and the business became O. Sleeper and Sons.

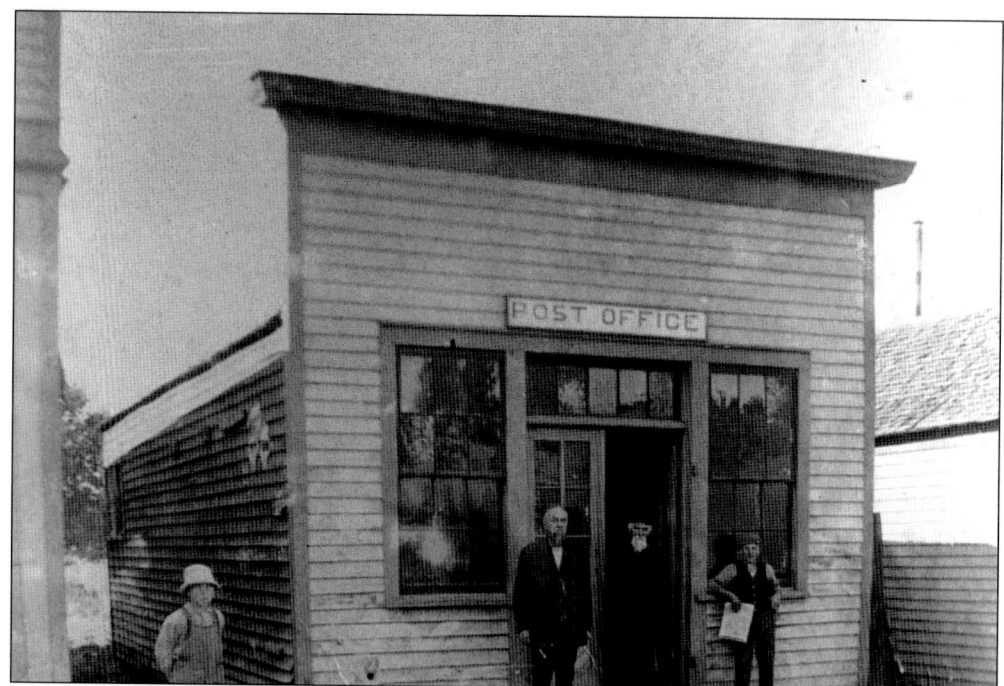

The Brownsdale post-office was established in 1856, the same year as the Austin post-office. The mail came to Brownsdale on horseback once a week from Austin, later by stage coach until the railroads came through in 1870. John Johnson was the first postmaster in the fall of 1856.

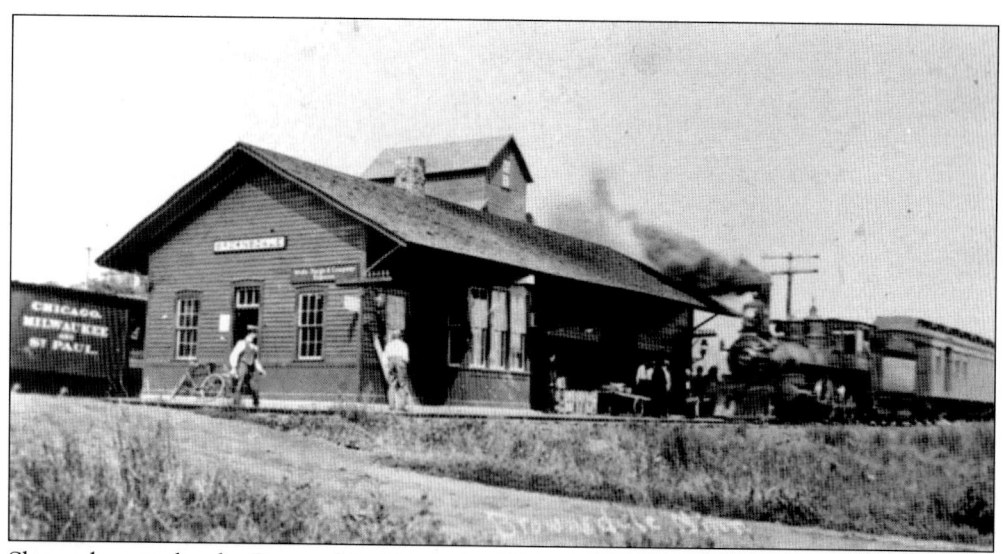

Shown here is the the Brownsdale Depot. In 1870, the Southern Minnesota Railroad built a line from LaCrosse, Wisconsin, to Austin. Later this link was taken over by the Milwaukee Railroad. In later years, automobiles and trucks became popular and the railroad lost some of its importance to the area.

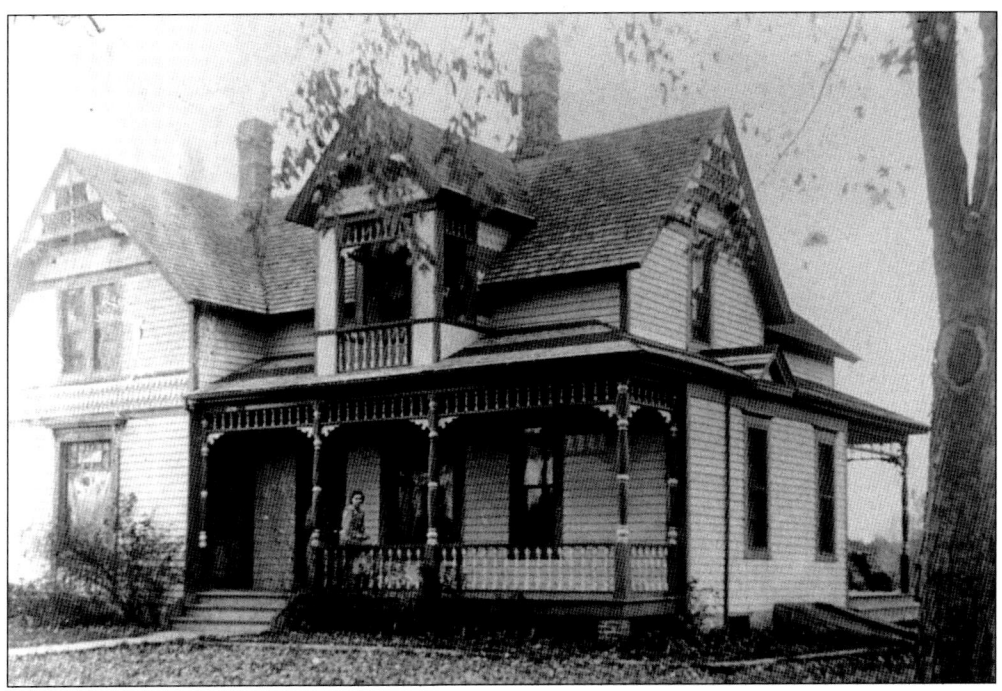
This is the residence of W.H. Lawrence of Brownsdale. Notice the lovely wood porch and upstairs balcony.

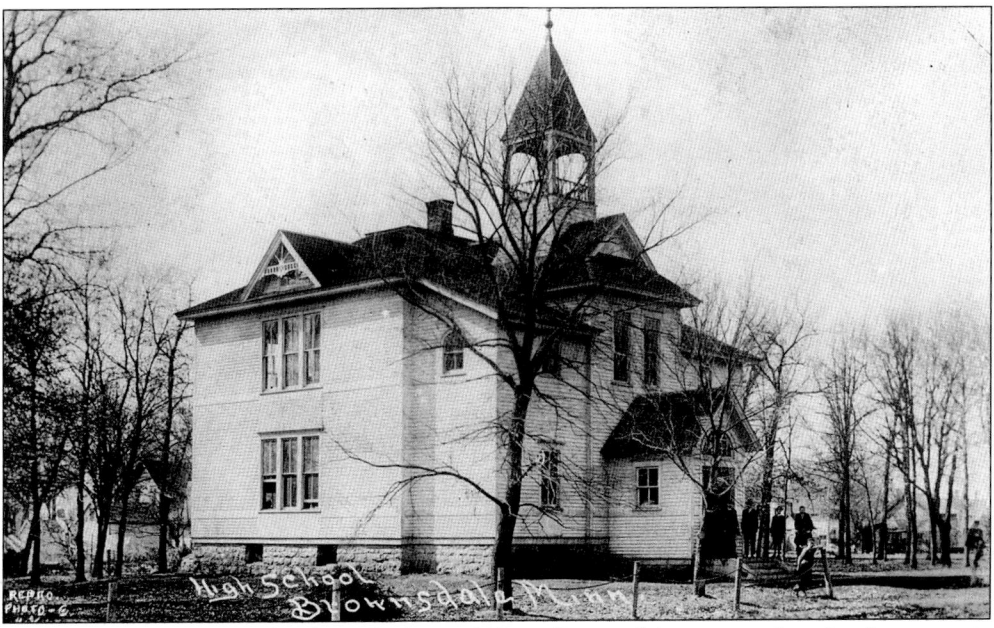
A two-story, four-room school was built in 1897, in Brownsdale, in time for school to open in the fall. It is now an apartment building.

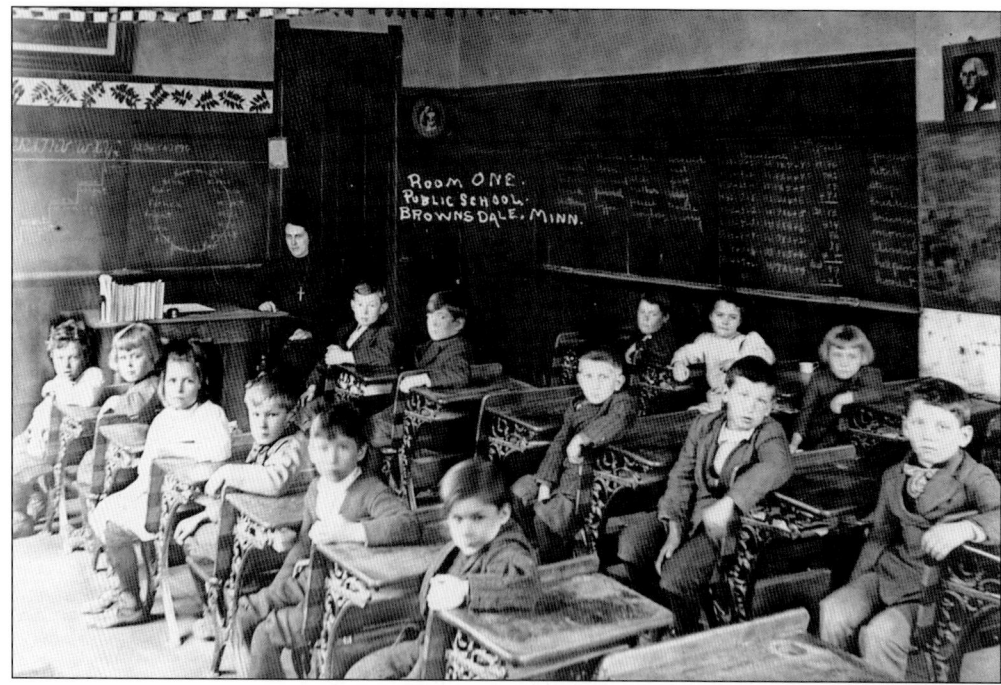

Here is the Room One class of Browsdale Public School. Notice the desks, black boards, and picture of George Washington.

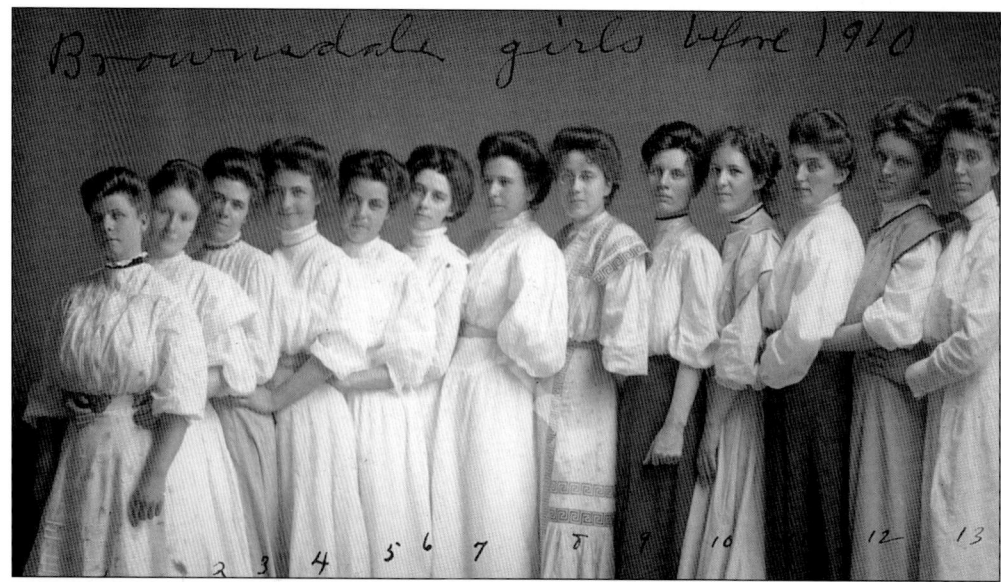

These Brownsdale girls, from left to right, are Marian Stephenson, Florence Peet, Alice Tanner, Grace Stephenson, Blanche Knox, Genevieve Hunt, Laura Gransee, Minnie Gransee, Mattie Hillier, Edith Palmer, Clara Rettigg, Jessie Hillier, and Lizzie Hill. The photo was taken sometime before 1910.

Pictured here is Trinity Evangelical Lutheran Church in Dexter Township, 1981. The first services were held in the Maple Leaf School District 106, Dexter Township, while the church was being built.

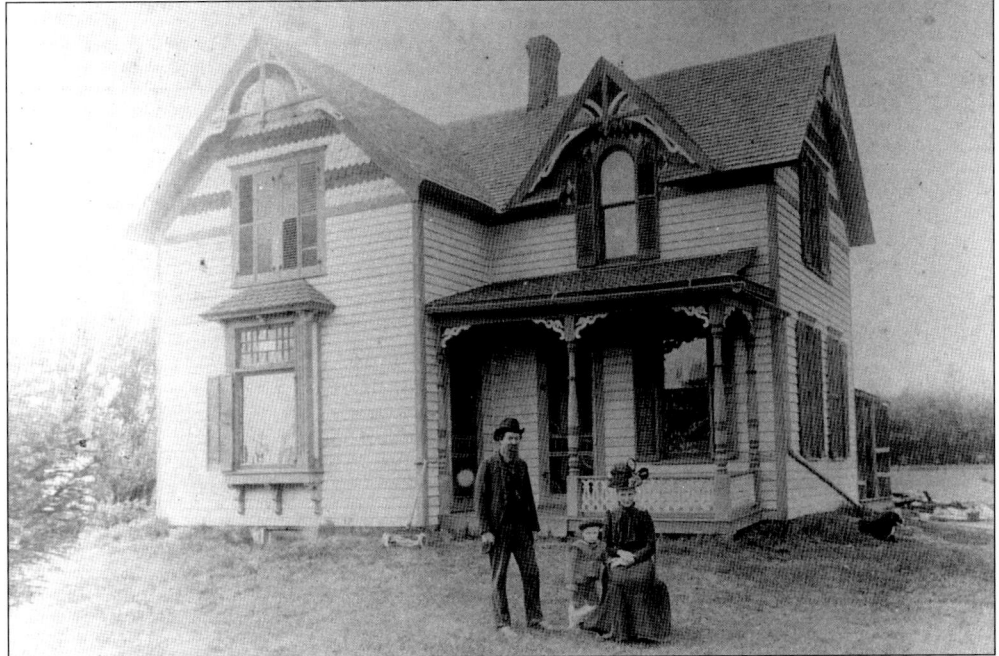

Residence of James and Hattie (Roelof) DeYoung and son Ralph is shown here. Ralph DeYoung was born in this house in 1895. James DeYoung built this house in 1894, northeast of Dexter. Note the fancy hat Hattie is wearing. From the *Grand Meadow Record*: "John DeYoung lost a team of horses today. His son, James was plowing and passing near an old well one horse stepped on a board which gave way and both horses and the plow fell to the bottom of the well, which was 20 feet deep. One horse was taken out alive, but probably cannot be saved. The other horse was left in the well."

Renova, a small village in Mower County located between Dexter and Brownsdale, was established when the Chicago Great Western Railway came through in 1887. A town-site was platted but was never settled. The elevator operated for several years, but with the advent of good roads and trucks it closed.

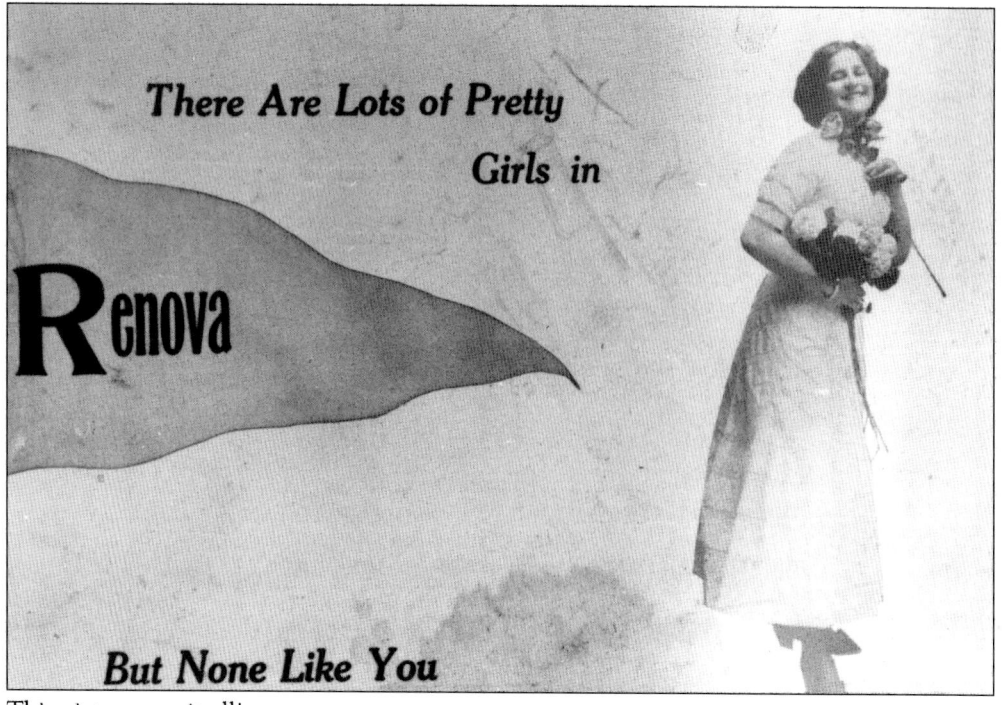

This picture says it all!

The Maple Leaf School, District 106, was built in 1891 in Dexter Township, Section 29. Some of the students were Victor Christgau, Gunther Rolfson, and Laura and Helen Studer.

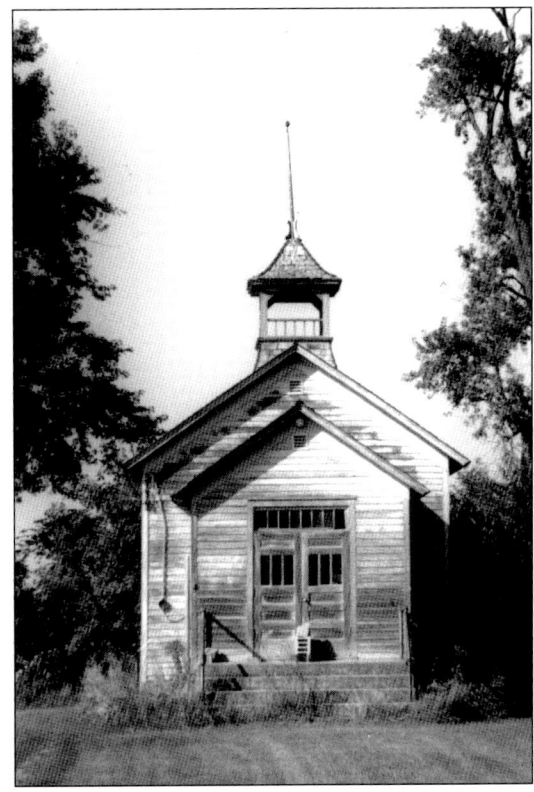

Pictured here is the home of Henry, Charles, and Mary Revo and children in Dexter Township.

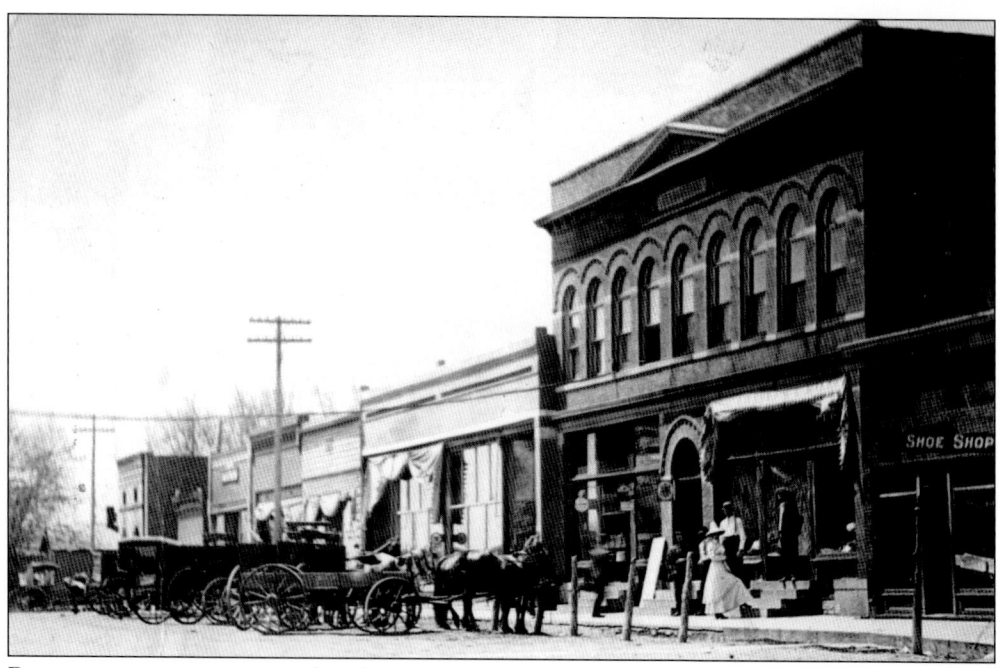
Dexter was given its start with a flag-raising ceremony. Organized in 1870, Dexter was named for Dexter Parritt, son of the first Dexter settler, Mahlon Parritt.

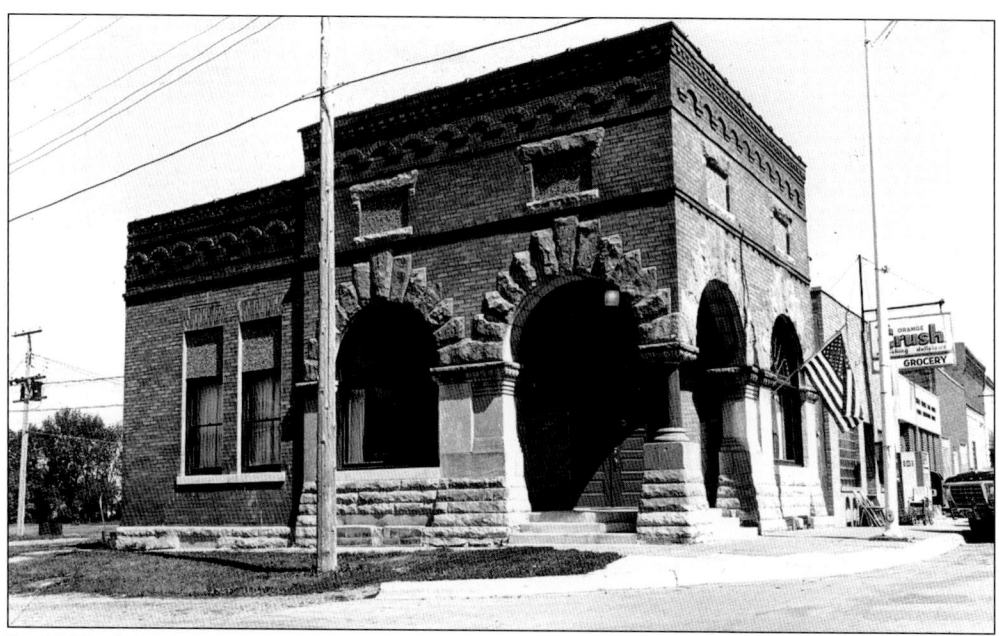
In 1907, four percent was paid for deposits, and left twelve months at the State Bank of Dexter, Minnesota.

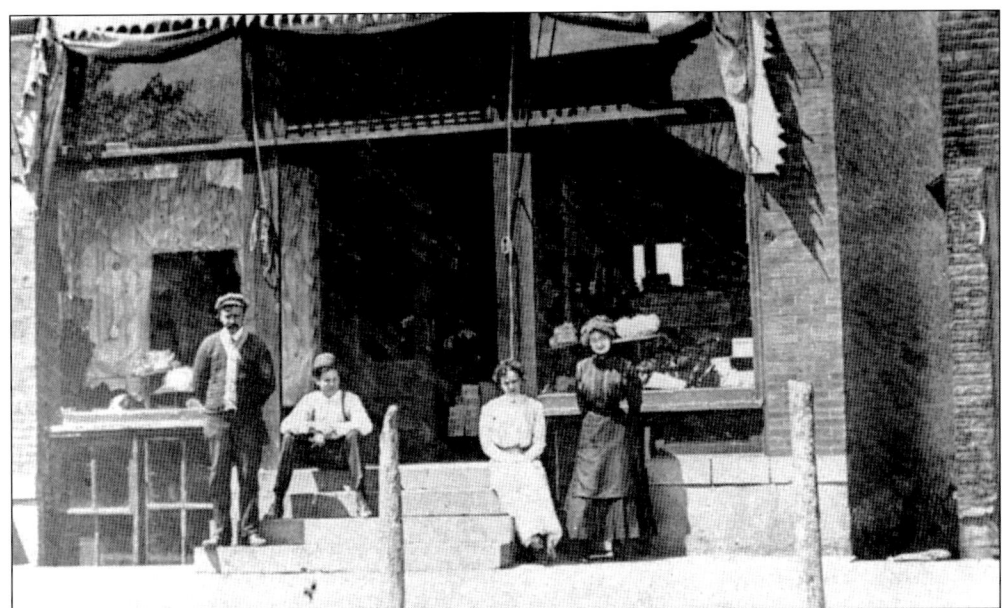

C.V. Miller sold fresh fish for 4¢ per pound at his store in 1909. Mr. Miller shipped several car loads of potatoes, some going to Iowa. C.V. Miller was in for a surprise when he advertised to give a dollar cash prize to the person bringing in the most eggs. As a result, 720 dozen eggs were marketed at his store and the prize went to John Rahilly, who brought in 68 dozen. In 1918, C.V. Miller had his store wired for electricity.

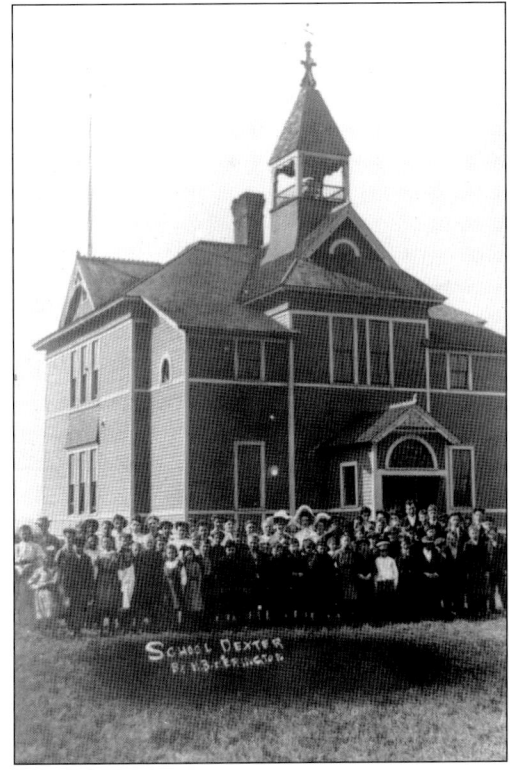

Shown here is the Dexter School House, a two-story building surmounted by a bell tower. A popular sport in Dexter was "glass ball" (marble) shooting. In 1917, children under the age 16 years were not to be alone on the Street after 9 p.m. The school bell would ring at 9 p.m.

31

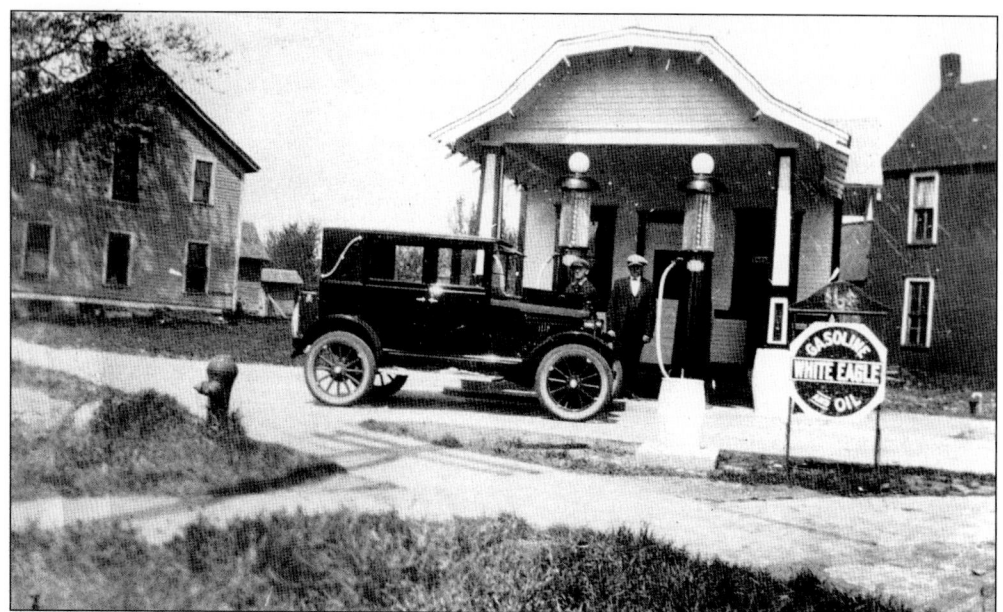
Ben Kraft's White Eagle was the first gas station in Dexter in 1924. In 1925, Ben Kraft sold his White Eagle Gas and Oil Station.

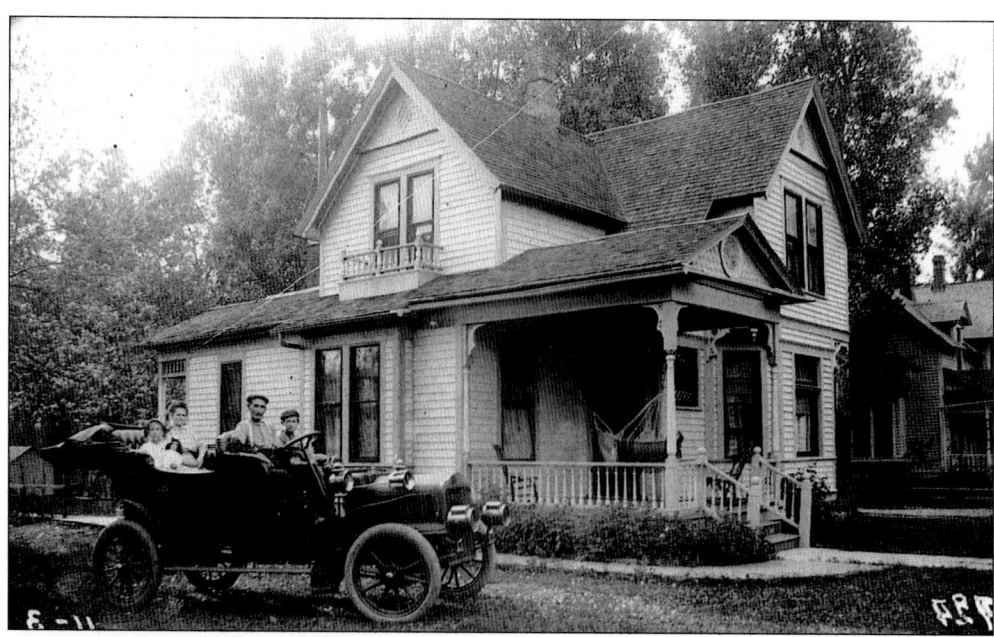
Shown here at the Nelson Medberry family residence, in an automobile, are Bertha Nelson and daughter Juanita (holding the doll) in the back seat, with father and son in front, c. 1909.

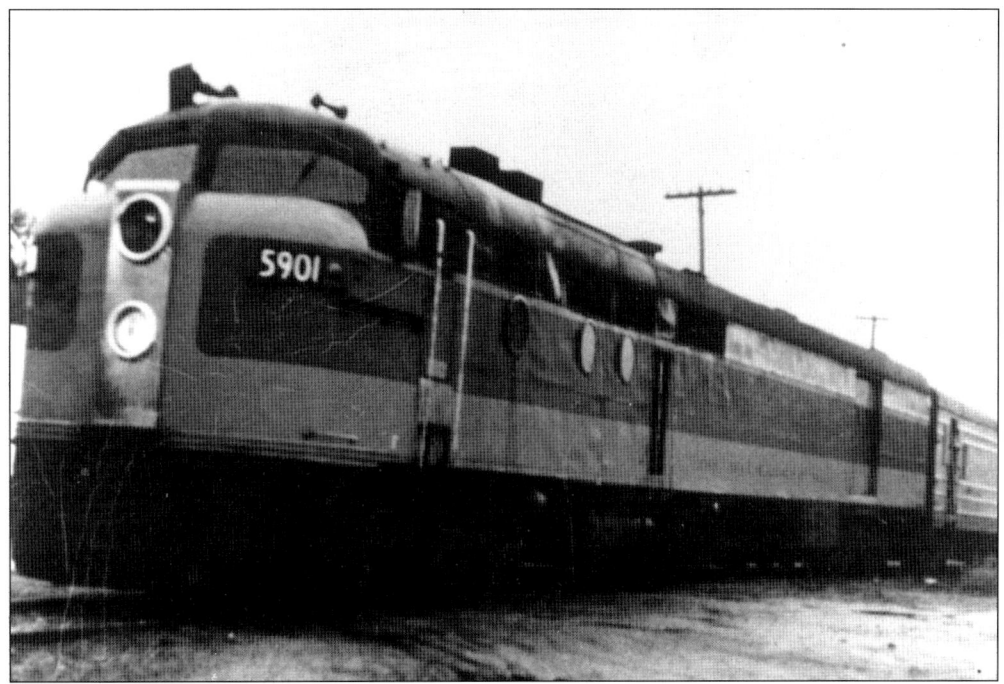

On March 30, 1960, the last passenger train passed through Dexter. People were traveling in their automobiles now and using the railroad for traveling less, so another era in Dexter came to a close. Special trains were dispatched to the area villages when the Mower County Fair was on. Then people could go to the fair and back home the same day on the train.

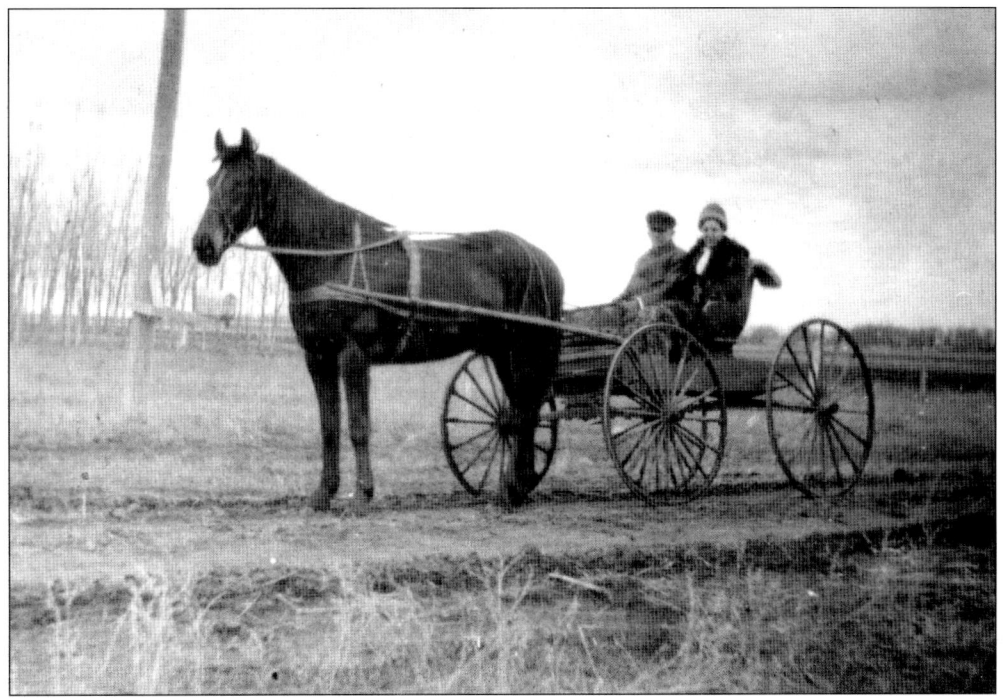

Leland and Celia Vermilyea are out for an afternoon ride in the country by Dexter.

Here is Sam Goetsch's Land Office as it was early in the 1900s.

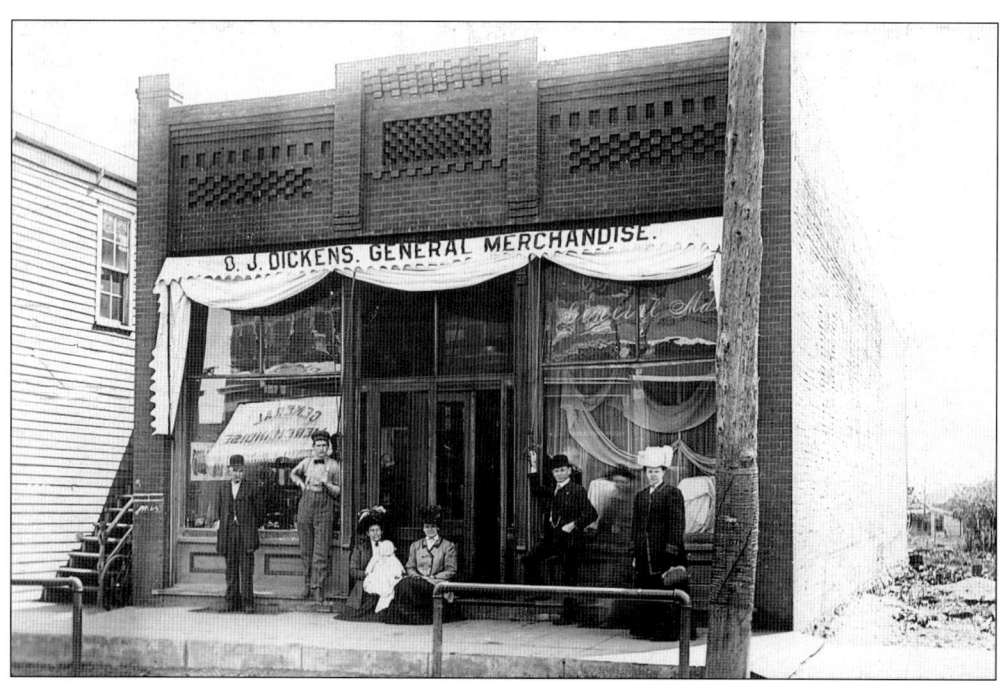

Shown here is O.J. Dickens General Store in Dexter.

Four

Pleasant Valley, Racine, Frankford, Grand Meadow

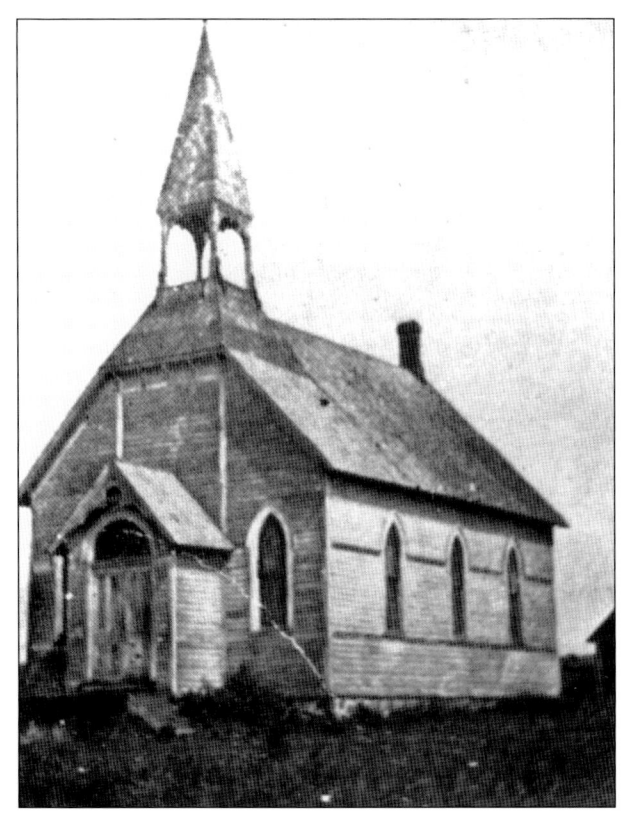

The first marriage in Pleasant Valley was that of Lydia Hills and Albert Barlow, in the spring of 1856. The ceremony was performed at the home of the bride's parents by Los Dutton.

Shown here is Pleasant Valley Town Hall, Pleasant Valley Township.

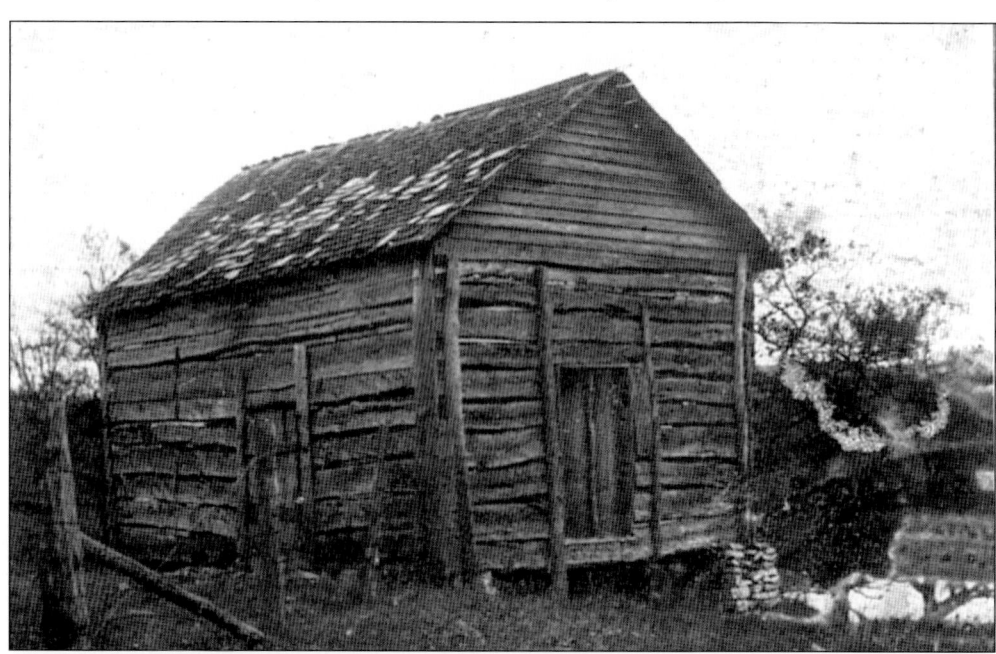

The first pioneer of Pleasant Valley may well be accorded as Sylvester Hills, who arrived here with his son Byron in 1854. He made a claim on Section 11 and returned to spend the winter in Wisconsin. In the spring of 1855, he returned to Minnesota with his family, they made the journey with ox teams, wearily plodding by day, camping at night. Mr. Hills soon built a good 22-by-32-foot, 14-foot high log cabin.

Here is an early scene at the Link Gravel Pit at the site of the Racine Quarry. In the background of this photo, near the steam shovel, are the owners, Mr. and Mrs. Joe Link, Louise Link, and shovel owner Mr. Haney. On the cab of the Model T (third truck from left in foreground) are Ted Chamberlain, Frank Eppard, and Alonzo Darrall. On the second truck is early Ford dealer, Jens Peterson.

The early days of win-rowing hay by Otto Urban of Racine, his dog resting by wheel, are captured in this photo.

This is the water tank on the wagon in which they hauled water for the steam engine for threshing.

Verner Lyman's mail buggy was used in the 1920s and 1930s, when dirt and gravel roads were nearly impassable. Horse drawn vehicles were the only means for winter and spring months, while wagons, sleighs, and cutters were also used.

One of Verner Lyman's vehicles was this 1940s converted panel truck fitted with airplane tires. Verner often drove through fields and ditches to get around blocked roads and deliver the mail.

The first creamery in Racine was built in 1893, the building was destroyed by fire in 1905, but was promptly rebuilt.

Two brothers and two sisters enjoy a ride in their 1912 Overland Car! Out for a neat drive in Racine Township are Frank Urban (driving), his brother Otto Urban (beside him), Minnie Urban (left back seat), and Edith Urban (right back seat).

Here is a view of Main Street in Racine, Minnesota. Racine is a village on the Chicago, Great Western Railroad, on the southwest quarter of Section 26. It was platted in October of 1890. S.H. Sleeper erected the first dwelling in the village in the fall of 1890.

"You Can't Swing Your Partner Anymore" Racine Café and Dance Hall on the north side of Main Street in Racine was a fun place for many people. It has broken windows and a weathered door, but the memories are of good times in the Old Dance Hall.

The Racine Post Office was established in 1878, at which time T.W. Stewart was appointed postmaster. The post office was used as the Racine town hall for many years.

Shown here are the display cars during the Racine Steam Engine Days.

Show here is the Johnson residence, Racine.

In 1912, two Chicago Great Western locomotives collided head-on about two miles southeast of Racine.

The Congregational Church at Hamilton, Minnesota, was established in 1873, and around 1898 it was sold to the German Lutheran Church for $500.

Shown here are the bubbling springs at Hamilton, Minnesota.

This is the site of the Old Frankford Stone School House. This was the first school house in Mower County, built in 1867, in Section 24. The first teacher was N.W. Boyes.

Bear Creek Lutheran Church was built in 1869-1870. The church was dedicated on June 20, 1887.

Oxen were used for farm work as well as to pull the wagons. They were very strong.

Summer wasn't summer without the Bear Creek Boys. The band was organized on June 14, 1889, at the home of C.C. Skogstad. Sixteen members made up this group of band boys. Pictured in this 1902 photo of the Bear Creek Band, from left to right, are the following: (front row) John Simonson, Martin Simonson, and Carl Skogstad; (middle Row) unidentified, Ed Simonson, Olaus Simonson, Henry Simonson, and Otis Skogstad; (back row) Simon Severson, Emil Skogstad, John Jorgens, Halvor H. Hanson, and Clarence Skogstad.

This is the Bear Creek Band's 50th Anniversary in 1939. Pictured, from left to right, are the following: (front row) Sanford Jorgens, Ed Simonson, Olaus Simonson, Martin Simonson, John Simonson, Lynn Wilsie, Simon Severson, and Halvor Hanson; (back row) Oscar Myhre, Clifford Lindelien, Gabe Severson, Rudolph Hartje, Edmond Hanson, John Jorgens, Halvor H. Hanson, Orville Olson, Leo Schroeer, Mr. Hartje, Ben Lindelien, and Halbert Simonson.

The depot was the oldest building in Grand Meadow, built in 1871. It closed in the 1970s.

The Nolan Auto Company was incorporated in 1910. In 1920, Martin and Schroeder purchased the garage from W.A. Nolan Company.

The blacksmith shops and livery stables were doing big business in the early 1900s. Pictured are Tom Grimes and Paul Grimes, the building was located near the east end, south side of Second Street, c. 1883.

What a fancy car, with driver William Lewis, parked in front of the furniture store in Grand Meadow.

Shown here is the Grand Meadow Record Company Building. The first newspaper was called the *News*. It was started in 1878, by the Dunlevy Brothers, and ran for two years. Another paper, also called *News* was later established in the spring of 1880, by M.V. Scribner, a photographer. That paper lasted about one year. The *Grand Meadow Record* had its first issue in December, 1882. L.G. Moore founded this journal.

Christgau Machine Works, also known as the Henry Christgau shop from 1934 to 1974, would often find Henry with his "Avery."

49

Pictured here is a threshing crew near Grand Meadow. What a lot of work for this crew to thresh for one day or two. The wives had to cook meals for this hungry group, along with pies for dessert.

In 1903, this Grand Meadow High School was built for $6,000. The first four year graduates were Mattie Bratrud and Volney Davis. In 1916, the building burned (perhaps to the delight of some of the students).

Take a look at this fine looking Girls Basketball Team from Grand Meadow in 1911. Do you know who they are?

This lovely Brick Opera House with an ornamental front was built in 1910 by the Woodmen Lodge of Grand Meadow. It became a center of village activities for many years. The building was 50-by-100 feet, at a cost of $7,000, and the Grand Opening was January 7, 1910. Early in 1950 the building burned.

In 1885, 16 men formed an organization called Grand Army of the Republic (GAR). C.F. Greening was their leader for 16 years. In 1891, this group built the present GAR Hall on South Main Street, Grand Meadow.

The Great Old Veterans at the Grand Meadow Cemetery: Mr. Johnson, Mr. Pierce, and Mr. Conlon.

What a picture, take a good look: this is a women-less wedding, held at the Opera House in 1930, in Grand Meadow. Note the bride and groom and also the small wagon on the floor on the right side.

The Bussell Hotel of Grand Meadow was built by Harry and Eliza (Requa) Bussell in 1925, a thing of beauty inside and out built with fine brick. It had eight spacious guest rooms, steam heat, and an elegant bath. Harry and Eliza were the grandparents of Shirley Bussell DeYoung, Director of the Mower County Historical Center in Austin, Minnesota.

The East Cranewood farm was owned by Ralph E. and Florence E. (Wood) who were married on May 14, 1884. Mr. and Mrs. Crane had eight children: Clarence E., Benjamin W., Maud M., Rollin E., Webb, Wade, Sydney A., and Florence E. Ralph raised Aberdeen-Angus cattle, Percheron horses, Hampshire swine, and Oxford sheep.

First American State Bank sits on the northeast corner of Main and First Streets, it is a fine example of the "Prairie School of Architecture." Built in 1910, it was the first bank designed by William Gray Purcell and George Grant Elmalic to actually be constructed. The First American Bank Building was originally the home of the Exchange State Bank, founded in 1871.

54

Five
Bennington, LeRoy, Clayton, Lodi, Adams

Bennington Lutheran Church was organized on May 15, 1896. Rev. O.A. Bu, pastor of the Bloomfield Lutheran Congregation, presided over the meeting. For the first five years, services were held in the Norby Schoolhouse. Building of a new church was started in 1900 on a site given by Ole Bratrud. The church was completed in 1901 and dedicated on June 1, 1902, at a total cost of $1,600.

Here is a view of LeRoy's Main Street looking west. Note the interesting parking arrangement in this early 1920s photo.

Bethany Lutheran Church located north of LeRoy was built in 1905, and replaced a smaller building that was torn down. The first church was built in 1878 at a cost of $821.26.

Here is the entrance to Wildwood Park, LeRoy, Minnesota. Wildwood Park became Lake Louise State Park in 1963. In 1927 Frank Hambrecht donated seven acres of land to the village of LeRoy for a park at the Old Town with the stipulation that a dam be built across the Upper Iowa River. It was the nucleus around which the town purchased an additional 28 acres of woodland and built their beautiful Wildwood Park.

This was the first dam at Wildwood Park, LeRoy, Minnesota.

OAKDALE PAVILION
LeRoy, Minn.

This dance pavilion at Oakdale was about the finest in Minnesota in the 1920s. Cy Thompson, the proprietor, hired famous bands out of cities like Chicago and New York. Crowds came from as far as Minneapolis. The weekends attracted thousands of people to this entertainment resort. Besides dancing, there was roller skating and swimming, for there was an outdoor swimming pool.

What a lovely lady. Louise Hambrecht, sister of Frank Hambrecht, is seen here in LeRoy. Note the attractive hat.

A two-story brick school building was built at a cost of $5,000 in 1868. The first class graduated in 1892. Members of that class were William Allen, Anna Kasson, Maude McKnight, Henry Bishop, and May Avery.

Taking time out to pose for a photo were the LeRoy Ladies Bicycle Club members. This photo was taken at the turn of the century when the roads were still dirt and difficult to ride bikes on.

Members of this LeRoy Cadet Band in 1907, from left to right, are as follows: (front row): Henry Hague, Archie Wells, Sid Broadbent, and Harvey Shepard; (middle row) Harold G. Clapper, Will Sanders, Barlett Butler, Howard Martz, Walter Garvey, Earl Frisbee, and Swen Peterson; (back row) Guss Voss, Bill Palmer, Dr. J.L. Day, director (dentist), Walter Hall, Robert Malcomson, Elmer Thompson, Stub Wyckoff, John Hall, and Arlo Palmer.

The Frank Farm, owned by Hon. John Frank, bordered the west edge of LeRoy. It was well supplied with timber, some of which was located so as to make a splendid shelter for all the stock and buildings. Their livestock consisted primarily of a large number of horses, sheep, and hogs, as well as two-hundred head of cattle. They also had a cheese factory on the farm for the manufacture of their milk into cheese.

Pictured here is the Frank Farm Barn

Here is the Chicago, Milwaukee and St. Paul depot of LeRoy. Many trains came through and picked up passengers for work and pleasure throughout the years.

Shown here is the LeRoy Home Guard in 1918.

The Clayton Town Hall was School District 74.

Taopi derived its name from the celebrated Indian Chief "Taopi" who befriended the settlers at the time of the New Ulm Massacre. Shown here is a 1972 Aerial View of Taopi.

The Taopi School was built in 1914. It served as a grade school and high school. The school building was sold in 1962.

The Taopi Hotel was built in 1876.

The Taopi Covenant Church stood from 1870 to 1990.

Shown here is the Taopi Depot.

Sawing logs in the winter time is Bill Christopher of Adams, Minnesota, 1918.

Tollef and Maria Olson were early residents of Adams. Tollef was born in 1828 and Maria in 1832.

Pictured in this photo at the Anderson Farm Home in Adams, from left to right, are Mr. and Mrs. Ole Anderson, Peter Anderson, Mrs. Josie Johnson, and Mrs. Wignes.

Here is a country school in Adams Township; note the hats on the boys in the back row.

Pictured in this photo, from left to right, are as follows: (front row) Mrs. Thrond Bohn, her daughter Emma, and Mr. Thrond Bohn; (back row) Simon, Mattie, Sophia, and Amelia.

Johnsburg, or Johansburg, as it was formerly called, is an old settlement in Section 32. When Peter and Christina Freund moved to Johnsburg in 1880, they had no idea that the store they established in that year would provide their family's livelihood for almost the next 90 years. In 1895, the Freunds built a much larger store and house in Johnsburg, which still stands today.

Shown here are John Mullenbach and his cousin, Vincent Mullenbach, of Johnsburg. Price of the car was $168 with the license.

Here is a 1900 photo of the Gerhart Threshing Rig, Johnsburg, Minnesota. Owners of the Rig are W. Gerhart, J. Mullenbach, S. Klapperich, F. Gerhart, M. Mullenbach, and N. Ulwelling.

Here is a view of Fourth Street, Adams, Minnesota. The Village of Adams was platted January 30, 1868, by Selah Chamberlain. Note the truck parked in center of street and other cars as well. The first couple to be joined in holy bonds of wedlock in Adams Township was M. Krebsbach and Susan Bandes. The grand event took place in September of 1858.

Here is the Adams consolidated school as it looked in 1917. The bus service was horse-drawn. The first class to graduate, in the spring of 1918, were Mary McGravey, Gert Schneider, and Rosie Zilz.

One of the early baseball teams of Adams Township, posing here from left to right in Lyle, Minnesota, are as follows: (front row) Steve Anfinson, Williamm T. Krebsbach, Warren Dean, and Jon Meurer; (back row) Theo Nelson, Frank Scanlon, Martin Johnson, Joe Mandler, Joe Carey, Ed Bertram, and Thomas Mulady.

This photo captures the Hotel in Adams in 1901. Mrs. Erick Weness is seated in the rocking chair, others unidentified.

The Adams Community Band, posing for this 1907 photo, from left to right, are as follows: (front row) Art Sjobakken, Ben Korst, Fred Krebsbach, Ed McDonough, Bill Krebsbach, Ed Schmitz, and J.F. Schneider; (back row) Oscar Torgerson, Al Schneider, Arnold Nett, Andrew O. Sjobakken, N.P. Schmitz, Joe King, Ed Schneider, John Sjobakken, N.V. Torgerson, and E.I. Thune.

Shown here is an Adams' telephone operator. Note the decorative stool she is sitting on and the long dress. Switchboards similar to this one were often located in private homes, so the operator was on duty 24 hours a day. Every telephone family had its own sequence of long and short rings, but because the phones rang in every home on the exchange, listening in on neighbors' calls (rubbering) was a popular pastime.

The Farmers State Bank, at the corner of Main Street and Broadway, was constructed in 1914. When the bank opened in 1915, it was one of the most modern in the country, and the teller cages were built of Italian Marble.

This photo is of the Little Cedar Lutheran Church in Adams. The cornerstone was laid in 1907, and the first service was held on March 22, 1908. Dedication of the church was held October 25, 1908, and a bell was installed in the new church on February 27, 1909.

The Adams Co-operative Creamery Company was organized February 25, 1898, and at once erected a new building. It was built of hollow Mason City Brick.

Shown here is the Andrew Torgerson residence, a lovely style of early homes. Andrew was one of the pioneers of this area.

A Sunday School class attends at the Little Cedar Lutheran Church of Adams.

Six
MARSHALL, WINDOM, NEVADA, LYLE

Hoflanda Swedish Lutheran Church, located nine miles east and two miles south of Austin in Marshall Township, was organized in 1883. The church was built in 1888. Its first pastor was Reverend Swan Anderson. The church is now closed, but not forgotten.

Here is a view Main Street of Elkton, 1976.

Look at the fine horse-drawn buses used for transportation to the Elkton school in 1918, slightly different than today's travel to school.

Shown here is Elkton School in 1918. The first high school class graduated in 1920 with four members—Herbert Anderson, Arnold Anderson, Alfred Hanson, and William Rogne. In 1970, Rose Creek, Adams, and Elkton voted to combine their schools.

Pictured here is the Elkton High School basketball team of 1925-1926. From left to right, they are as follows: (front row) Ervin Schwerin, Harvey Baxter, Elgar Ramseth, and Emmitt Scott; (back row) Jerry Hanson, Herb Hanson, Supt. Hunter, George Voorhees, and Bill Rabine.

E.H.S. CLASS 1932

The Elkton High School Class of 1932, consisted of the following: John Hase, Prof. F.R. Reeder, Louise Klaehn, Alice Ramseth, Gerhart Glienke, Raymond Hanson, Lucille Corbitt, Alice Tiedeman, Vanita Cooper, and Laura Corbitt.

Shown here is Saint John's Lutheran Church. The first church was 28-by-40 feet and very simply built. It was completed in 1887. In 1905, a resolution was passed to enlarge the church and add a steeple with a bell.

A passing scene in Mower County features Elkton's depot, one of the town's best known landmarks. It was built in the early 1900s and closed on October 1, 1957.

Here is a view of Rose Creek's Main Street looking south toward the elevator. Rose Creek was incorporated on February 14, 1899. Note some of the horses are covered with a blanket to keep warm.

On the right side of this photo is the Weinert and Jensen Store. Peter Weinert of Wisconsin erected a large brick building in 1906, and entered into partnership with Henry L. Jensen in general mercantile business. Note on the left is the C.R. Varco Store.

Here is a very early picture of the Rose Creek Band.

The Village Band of Rose Creek is pictured here, from left to right, as follows: (front row) Joe Leahy and Chas Martin; (middle row) Art Martin, Jake Hafner, Ernie Enright, Al Cramer, O'Halleran, Louis Nelsen, Tony Wienert, Carl Jensen, Art Landdeck, and John Gerhart; (back row) Everett Nelson, Joe Albright, Ed Anderson, Alvin Carlson, Frank Albright, Roger Cronan, Albert Ulwelling, Pete Schmit, and Thomas Nelsen. In the grandstand are Homer Hawkins, Saddler, Art Schammel, Norbert Landdeck, Joe Wendell, and Leo Cronan.

The Frank Ulwelling and Carrie Hangge wedding took place at the Hangge farm east of Austin, on July 8, 1903. Frank Ulwelling was the son of Nick and Margaret Ulwelling, and Carrie Hangge was the daughter of Frank and Louise Kaeser Hangge.

Barney Uschold and daughter Loretta are all dressed up and ready for a ride, c. 1908.

RESIDENCE AND FARM OF HON. J. J. FURLONG.

This was the home of Hon. John J. Furlong, son of William and Sarah (Carter) Furlong. Born in Ireland, February 2, 1849, he came to America with his parents in 1852. On May 25, 1880, he married Agnes Ryan. She died in 1897, leaving four children—May, Loretta, William, and Charles. For four years, he represented his district in the legislature. He was a member of the Sheep Breeders' Association of Minnesota and president of First Congressional Live Stock Breeders' Association.

Pictured here are Lloyd, Frank, and Lola Lonergan, children of Patrick and Amy Lonergan of Windom Township.

Residents of Concord Grange posing on February 4, 1948, from left to right, are A.M. Staley, August Sommers, William Rugg, C.E. Brugger, Henry Jensen, Everett Staley, Frank Smith, Tommy Jensen, Frank Perry, and Ben Stivers.

This photo shows Jack Majerus mail route transportation, c. 1900.

The 1930s Jack Majerus mail route transportation was a little different than the 1900s transportation.

Here is a Reinartz Case Steam Engine.

Shown here is the Thill Farm Home, Rose Creek.

85

A Thill farm tractor is plowing in Windom Township.

The Rose Creek depot was erected in 1878, and the first station agent was John Cronin, serving from 1878 to 1889.

Thill implement staff is shown decked out in Centennial beards in 1967. Pictured, from left to right, are Darwin Shoden, James Holder, Roman Smith, LeRoy Doe, Harold Felten, Vern Meister, Jack Thill, Betty Anderson, Clarence Mullenbach, Bud Fink, Erland Smith, George Draven, Jom Pitzer, Adolph Brown, Elmer Mullenbach, and Roger Osmundson.

The Six Mile Grove Lutheran Church was organized in 1859. It was one of the first Scandinavian Lutheran congregations in Mower County. In the spring of 1868, the church was dedicated. Rev. C.L. Clausen organized the congregation and served this parish until 1871.

Here is a view of Grove Street in Lyle, complete with boardwalks and dirt road, before the arrival of the automobile, 1902. The town pump and watering trough are on the left. Note the telephone pole on the right side of photo. Lyle received its name from Robert Lyle, a native of Ohio, who arrived in Mower County in 1856.

Here is a scene of Market Day in Lyle, 1908. Note the dirt street.

Dr. Willis Frederick Cobb served as a pioneer doctor in the early days. Dr Cobb made country calls by horse and buggy in summer, by horseback in muddy weather and by sleigh in winter snow. His first automobile was a red, chain-drive Buick.

One of Lyle's first rural mail carriers was John Carter of Lyle on Route 1. John Carter retired in 1927.

Lyle Public School, built in 1906, was the township's second school. This public school was erected at the cost of $15,000. Its first high school graduates were Odean Johnson and Enid Cobb, both of Lyle.

First prize went to Chris Olson for the largest load of Oats—190 bushels— on Market Day in Lyle, 1908.

Shown here is Our Saviors Lutheran Church of Lyle. The Reverend A.E. Moe was installed at the church in April of 1913, and the church was dedicated in June of the same year.

Pictured here is the J. Griffin family of Lyle Township.

City Hall of Lyle was erected in 1906. The ground floor housed the fire department apparatus, where the council chambers and various meetings were held.

Gunder Larson, of the Lyle area, had an 8-foot beard for Lyle's Centennial Days.

At one time in the early 1900s, Lyle depot had 14 passenger trains a day going through. During the Mower County fair, the passenger trains were kept busy with people going to the festivities, and ticket sales amounted to $150 a day. In 1965, the Milwaukee depot was removed.

Gustav L. and Lena (Anderson) Hanson were married on November 6, 1899. Five children were born to them. Gustav conducted general farming, having about 35 head of dairy cattle, 25 Poland-china hogs, and 8 horses.

"You Got Insurance?" Whose fault was this front end accident in 1914? Cars had to be shipped back to the factory for repairs, as there were no garages in the area. The first cars traveled with top speed of 20 miles-per hour.

Anton Ramseth is wearing a coon-skin coat of the popular style at the turn of the century—what a heavy looking coat to wear!

Halvor Hanson is disking with four horses and two mules. Note that Edmond Hanson brought his dog along, sitting on Halvor's shoulder.

Self-tying binder with a three-horse hitch, is seen here cutting and tying bundles of oats.

It's threshing time at the Oscar Studer farm.

Shown here is a threshing rig at Oscar Studer farm in the 1930s. Oscar is getting up in the world; he is topping the stack out.

Seven
Austin and Lansing

Mower County Historical Society's Pioneer Building was dedicated August 9, 1949, during the Mower County Fair.

The Historical Administration Building was dedicated on May 17, 1992, with the ground breaking event held in 1991. The research library has a vast amount of Mower County History. Hours are 10 a.m. to 4 p.m., Monday through Friday.

This Democrat wagon was donated to the Historical Society by Blanche Bedford Greiner and Helen Bedford Overocker Ashley, who are great-great-grand-daughters of the original owner, Robert Townsend Bedford, who drove this wagon from New York state in 1854 to his farm in Lyle Township, Mower County. It was restored in 1974 by Robert and Blanche Bedford Greiner.

The 1004 sits on the grounds of the Historical Center. The 1004 holds the distinction of being the last active steam locomotive on the Milwaukee. It was steamed up to handle the Austin-LaCrosse passenger train on March 16, 1957. A month later, it was retired from active service and soon thereafter, placed on display at the Mower County Historical Center.

The Austin High School Marching Band, marching here in a parade in Austin. Note the people on top of building on right side of photo, clock by Elams Jewelry store, Canton Café, Wallace's Clothing store, and KATE radio.

Austin Carnegie Public Library was completed in April of 1904, in Austin. The library building was of the Grecian style of architecture. It was eventually torn down.

Austin High School was completed in 1921. The first public school in Austin was organized in the summer of 1856. It was taught by Maria Vaughan in a log house, which was later occupied by Ormanza Allen for a dwelling.

In 1931, Austin National Bank consolidated with the first National Bank of Austin. The merged organization moved into the newly completed building, which was on the northwest corner of the same intersection at Main Street and Second Avenue.

The First National Bank, once occupying the corner of Main and Bridge Streets, is now at the northeast corner of the intersection of Main Street and Second Avenue. The bank was incorporated October 27, 1868, with O.W. Shaw as its first president.

101

FOX HOTEL, AUSTIN, MINN.

In 1890, Charles Fox came to Austin and purchased land on the corner of Water and Main Streets. In 1893, he erected a fine brick hotel and opened for business in October of that year.

In 1872, A.M. Fleck erected the Fleck House at the expense of $16,000. It replaced the old Fleck House, which was erected in 1857 as the Lacy House and changed to the Fleck house in 1866, being destroyed by fire in February of 1872. The edifice was a brick structure, three stories high.

The Austin Post Office was located at Bridge and St. Paul Streets from 1912 to 1964. An addition, which doubled the working area, was completed in 1932. Thirty-five men were employed at the post office. The postal history of Austin dates from 1856, when Alanson B. Vaughan, the town's first merchant, was appointed postmaster.

These lovely ladies are ready to take part in the Fourth of July parade. Note the steering wheel on the right side.

Dr. Samuel Paine Thornhill was one of Austin's early physicians. Dr. Thornhill arrived in the winter of 1869-1870. The imagination cannot, unaided by the facts, picture the primitive conditions with which the doctors had to contend: long and dreary rides, day and night, through rain, mud, cold, and snow.

Shown here is the oldest house in Austin, built in 1859 by George Baird at 320 South Saint Paul Street. George Baird married Charlotte Brown in June of 1855, and they came to Mower County looking for land, settling in Lansing, and building a log house. In 1861, he moved into Austin, where he served as the sheriff of the county for a time and later became postmaster.

Pictured here is the beautiful Eberhart residence in Austin.

George A. Hormel and Company is Austin's largest industry. In 1887, a young man came to Austin and started in the retail meat business. In November 1901, the company incorporated. The organizers were George A. Hormel, Herman G. Hormel, A.L. Eberhart, John G. Hormel, and B. F. Hormel. The packinghouse business was inaugurated, on the present site of the plant, in a small frame building in 1892. Six-hundred and ten hogs were slaughtered the first year.

Members of the 1922 Hormel's Men's Club Band, from left to right, are as follows: (in front) Halsey Cory and Jessie Y. Jones; (second row) Ed Veverka, Frank Helebrandt, Fay Rayman, J. Z. Rogers, Fred Rayman, F.E. Monty, Bill Bednar, and Chester Rush; (third row) Jenny Thome, Jack Hall, Floyd Ingalls, John Konovsky Sr., D.A. Richardson, Al Petrehn, Ben Bednar, Ed Bouda, John Konovsky, Jr., and Lester Clark; (fourth row) Roy Tedrow, O.J. Bachman, James F. Schradle, F.E. Nelson, Bob Brush, Jim Culton, and Nels Christopherson.

In 1912, the Austin Fire Station was built on the corner of Maple and Chatham (First Avenue and First Street Northeast). In 1895, the city hired its first team driver, Oscar Hill.

Shown here is the Mower County Jail in Austin, 1905. The sheriff's residence adjoins the jail and was located a few rods from the Court House on the east side of Chatham Street.

The Eberhart farm buildings were located on West Oakland Avenue to the west of the trailer park.

Eugene and Amy Varco Hart sit on the porch of their residence, south of Austin. Orrie Hart is with the bicycle.

COMPANY "G" 1907

Company "G" was organized in 1882, and by 1898, it was 139 strong.

One of the first Log Houses in Lansing was the "Lansing Landmark." The first to make a settlement in Lansing Township was H.O. Clark, known as "Hunter Clark," a name given to him from his being an expert hunter. He came to the township in 1853, and took claim on the northeast of Section 34. He built a log cabin a short distance northeast of where Oakwood cemetery is now located. He sold his claim to William Baudler, who took possession in May of 1855.

Shown here is the L.D. Baird home, northwest of Austin. L.D., the son of George Baird, was born in Mower County on October 17, 1857, on a farm in Lansing Township. He married Lila M. Hall and to this union were two daughters, Helen and Frances.

Nelly Mabel Vaughan was born April 13, 1866, in Lansing Township, married Roy Chaffee in Austin, and three children were born. Her parents were Phineas and Elizabeth (Frisbee) Vaughan.

Lansing Village was surveyed and platted in 1858 by Charles Carter for A.B. Vaughan, the proprietor. The first building on the site was a log house erected in 1855 by A.B. Vaughan for a residence.

The Ramsey Mill was located on the west bank of the Cedar River in Section 23, near Ramsey Junction. Matthew Gregson, the proprietor, commenced the erection of the building and dam in October, 1872, working on the foundation and dam that winter, and completing the mill the next summer in time for the next crop. The mill was supplied with four run of buhrs, which are run by water power. In the summer of 1884, rollers were added and a fine grade of flour was manufactured under the roller process.

Shown here is the McIntyre general store, Lansing. H.M. McIntyre, general merchant, commenced business in company with John Bartlett, under the name of Bartlett and McIntyre. In November of 1880, Mr. McIntyre purchased his partner's interest.

111

The Lansing State Bank was built in 1915.

Henry Fairbanks ran the Railway Hotel for one year and then sold to Mr. Harris. The Railway Hotel was used by people traveling on the trains.

The Lansing Hotel was built as a private residence by Patrick Eagan in 1860. It was first kept as a hotel by Benjamin Carll in the fall of 1864. He continued until the spring of 1867, when his son-in-law, William Brown, took over.

This picture speaks for itself: Henry A. Wood of Lansing.

The Lansing Co-operative Creamery was incorporated on February 15, 1894, with a capital of $2,500. It was located on Section 11, Township 103, Range 18 in a building purchased from the Lansing Cheese and Butter manufacturing company. A new building was erected in 1906. Old-timers tell of the long lines of horses and wagons bringing cans of milk into the creamery. That was a time for visiting and storytelling.

The Lansing Grange #649 was started in the fall of 1929, and in 1930 had approximately 100 members. The grange purchased the old Masonic Hall over the McIntyre Store in 1947 and transformed it into the Grange Hall.

The first school in Lansing's existence dates back to 1858, the year in which Minnesota became a state. Classes were first held in the small home of John Pettibone in the summer of 1858, with Ann Mathieson as the teacher. The old school, built in 1866, was taken down in 1915 when a new school building was constructed.

Pictured here is the Lansing School Rhythm Band. Some of the band members were: Eldred Mazuk, Milred Mazuk, Lloyd Yarwood, Billy Cart, Viola Thompson, Douglas Thompson, Rueben Schmidt, and Harold Rudd.

The Chicago, Milwaukee, and Saint Paul Railway Company, in October of 1867, built its road through the township of Lansing, entering the town in Section 3.

Lewis Thompson, also known as Lars Thorson, was the first Norwegian settler in Lansing Township. He was born in Norway and came to Mower County in 1856. He married Elase Tollifson, also a native of Norway. Mr. and Mrs. Thompson were the parents of nine children: Jennie, Carrie, Theodore, Edward, Maria, Olive, Ole, Lewis, and Aaron.

Daniel B. Vaughan was born in Clinton County, New York, on July 3, 1835, son of Benjamin and Johanna (Kimble) Vaughan. He arrived in Mower County in 1855, pre-empting land in the northwest quarter of Section 15, Lansing Township. In 1861, he married Elsie (Lyons), daughter of Joseph Lyons, and to this union they were blessed with three children.

Here is the Lansing Elevator.

Shown here is a type of log house built by families of Mower County. This one had some rock footings and a rock fireplace.

Farmers of Mower County, the Rhoades family, pictured from left to right, are Oscar, Charly, Omelia, and Mriah Rhoades. Note the two horses hitched to the buggy in background, the young fellow with his bike, and the windmill in background.

Eight
AGRICULTURE

This photo captures a group of people working on the old log house on the Furlong Farm to be preserved in the New State Park at Austin.

A log house like this one was used by many of our early pioneer families, and, as time permitted, they built other buildings and fences.

The Mower County farm had traditional requirements for that era. Notice the large two-story house, with a wrap-around porch, windmill, and barn. Also the four-horse hitch to do farm work and the car ready to travel.

Shown here are Frank Lonergan on binder and his wife, Lillie, standing in back of binder, with their oldest daughter, Mabel, standing to the side on the Tischer farm near Brownsdale, 1912.

Here is a really neat threshing scene taken in Mower County—wish we could identify these men and boys, and what a hard day or days of work they did.

A fine herd of sheep and a nice looking barn are seen in this farm picture. Note the buggy by the barn.

Some fine looking Holstein cattle are shown in this farm picture of Mower County.

This large load of hay is heading for the farmers barn. Look at the harnesses on the horses.

A farmer in Mower County plants the seeds for a crop to harvest in the fall.

This picture shows a farmer plowing the fields—and look, rubber tires on the tractor! Times are changing.

The corn was planted, cultivated, and when ready, cut and tied in bundles and put in shocks of about 30 bundles. A few weeks later, the shocks were hauled to the barnyard and stacked in a long stack to feed the cattle and horses.

A day was spent looking at this fine engine. Note the car/pickup and all the men wishing to drive that tractor with the fancy top.

This is a scene of drilling a field of oats with four horses in Mower County.

Here an Oliver tractor is disking the field. Farming has changed from horse power to tractor power. All the early farm work once done by horses is now done by modern tractors. Many acres are soon ready for seeding with the modern equipment.

The beans are ready and out comes the combine—what, no tractor?

Here is a scene of picking corn on a farm in Mower County. Mower County farmers, the old and the new, have had their part in each phase of the agricultural evolution. The typical settler who came to Mower County in the 1850s or 1860s began farming with a minimum of equipment. He had a wagon, a team of horses or a yoke of oxen, a plow, and some hand tools such as pitchforks, scythes, and grain cradles.

Just one more threshing picture—they are so wonderful. What a great "early years" picture of threshing. Notice the hay wagon on the left, drawn by oxen, the buggy with two men checking on the threshing crew, a fellow to the upper right pitching his bundles of oats into the machine, another man sitting on wagon on the right, and horses catching a little grass to eat.

The Stock farm of A.W. Edson, Austin had horses, sheep, ducks, chickens, and cattle.

Milking the cows every morning, every evening, and every day! And no milking machine—just a small stool to sit on, a pail, and your hands to do the work to get the milk in the pail.